withdrawn

own Bown 1947-1967

Unknown Bown 1947-1967

Introduction by Germaine Greer

The Observer

For Luke Dodd. JB

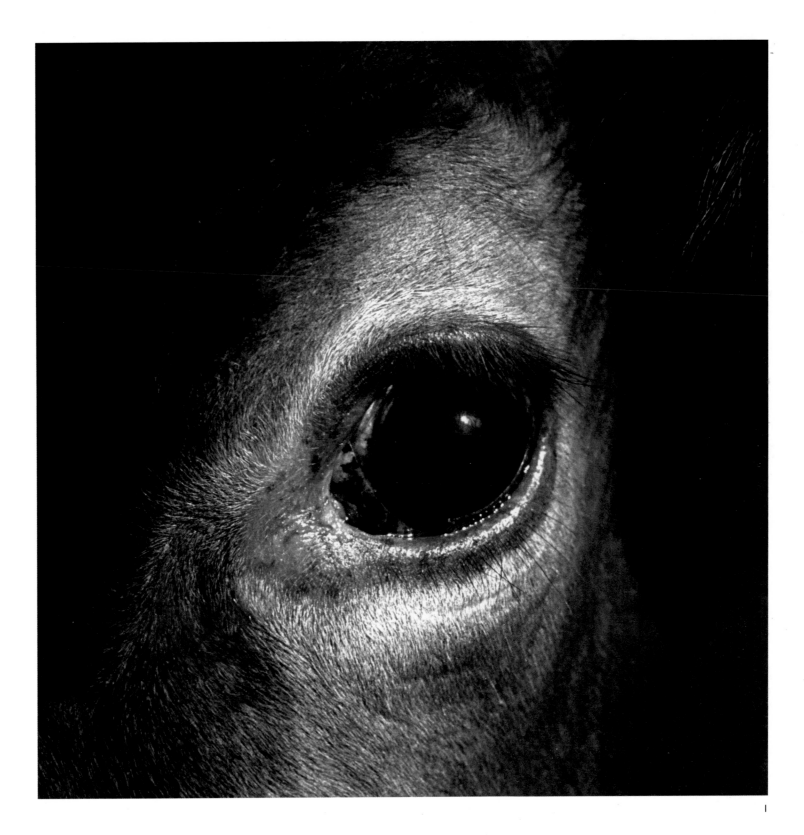

Introduction

Jane Bown's portrait photographs are well-known. Week on week they have been appearing in the *Observer*, where her first portrait, of the philosopher Bertrand Russell, was published in 1949. That portrait, along with forty-four others by Bown, is now in the National Portrait Gallery, but Bown is a far cry from being England's Annie Leibovitz. She never stage-manages her subjects, brings neither props nor lights nor assistants to an assignment, just one of her forty-year-old Olympus OM1 cameras, with a 50mm f2.5 lens, possibly in her shopping bag. She waits while her subject is being interviewed, observing all the time, and then she quickly snaps two rolls of black and white film. The subject is taken momentarily unawares, the session over before there has been time to assume a public mask. When Bown was at Buckingham Palace to collect her CBE in 1995 she demurred politely when the queen called her an artist. 'I'm not an artist,' she said. 'I'm just a hack.' The understatement was characteristic but there was a time when she might not have uttered it.

In 1946 twenty-one-year-old Bown, newly demobbed from the Wrens, managed to wangle a place in the photography class conducted by Ifor Thomas at the Guildford School of Art. (The Guildford School of Art which has now been absorbed in the West Surrey Colleges of Art was both pioneering and prestigious; its most famous alumnus is Elisabeth Frink.) By the beginning of her second term at Guildford, when Bown borrowed £50 to invest in a second-hand Rolleiflex she had committed herself to serious photography. The Rollei (which is still the camera of choice for David Bailey) was then the only camera for art and magazine photography. Ifor Thomas soon realised that Bown 'had an eye' and instilled in her the solid compositional values that can be seen in the best of her early work, whether she was photographing children on the beach (99), a ball of yarn on stony ground (83), hop poles against the sky (3), or a sleek, young shark dying on the shingle (41). The square picture had to be composed first of all by the eye and then framed (the image appears back to front in the viewfinder on top of the Rolleiflex), the exposure set, not by use of a light meter but by judging the intensity of the light on the back of her hand, and the picture shot, once. In a self-portrait with the Olympus she used later, Bown shows her eyes looking over the camera, as if identifying the shot before she looks through the viewfinder — a last reminder of these early days of looking, framing, finding the light, positioning herself and then — all or nothing. The pictures she took in the Rolleiflex years embody the best of the formalist aesthetic of the '50s and '60s, the kind of orchestration of line and mass that was celebrated by the much-lamented Adrian Stokes, in his seminal *Smooth and Rough*, published in 1951.

Though Bown claims not to have been aware of the work of Henri Cartier-Bresson until later in her career, her sensibility seems to have most in common with his. Cartier-Bresson too refused to allow his photography to be called art. He and Bown both describe themselves as 'prowling' in search of pictures. The pictures Cartier-Bresson found with his Leica are wonderful because of his artist's eye choosing the frame, the depth of focus and the distance from the subject, often in a split second, what he called the 'decisive moment'. Cartier-Bresson minimised the artistry of his photographic

work because of his deep faith that the photographer's highest duty was to actuality. The objective was, in Cartier-Bresson's own words, 'The simultaneous recognition in a fraction of a second of the significance of an event as well as the precise organisation of forms which gives the event its proper expression.' Bown is saying much the same thing more simply when she says, 'Some photographers take pictures; I find them.'

At first child photography was Bown's bread and butter; when she escaped from the studio and rambled about the country she was after something different, something special. In 1952 when she set off with her camera, whether to Eton, Crystal Palace, or Cowes, she was on the same quest as Cartier-Bresson. At Eton she found an Old Boy leaning on his cane, trilby tipped to match the slant of his dropped shoulder, left foot shot forward to counterbalance the angle of the cane (91). He looks with pursed lips and narrowed eyes at the young woman with the camera, deciding perhaps whether to tell her to 'bugger orf'. He probably thinks he is the subject of the shot, but he shares the frame with a female companion who sits almost at ground level behind him, hunched and hidden by layers of organdie, defending her legs with a big white handbag. The picture crackles with tension which Bown neither explains nor resolves.

In 1957, long before she began regularly to shoot portraits, Bown snapped (her own word) Cartier-Bresson, who was so averse to being photographed that when he was collecting an honorary degree at Oxford he shielded his face with a sheet of paper, squinting into the viewfinder of his Leica, with more than half his face obscured. Photographs of Jane Bown are as scarce as photographs of Cartier-Bresson. The most productive years for what is now called her photojournalism were the '50s and '60s, the years spent raising her three children. Bown was moved by children as subjects, whether they were hanging round the hop-pickers' encampments (15, 65, 68, 81), or struggling with schoolwork on a blackboard (56), but, unlike many other women photographers, though she filled photo albums to commemorate the usual family events, she almost never used her own children as subjects in her serious work.

These days Bown is more likely to remind people of Robert Frank, Cartier-Bresson having been ranked with the immortals. Cartier-Bresson collected ten international awards for photography, Bown has none. Nevertheless if we are to assess the best of her photojournalism it is to Cartier-Bresson that we must turn to find her soulmate. Frank looks on America with an outsider's eye; the faces he photographs in the street are the hard-edged faces of strangers. The images that Cartier-Bresson found on the streets of Berlin, Brussels, Warsaw, Prague, Budapest, Madrid, Beijing, Delhi or Paris are very different. Though we cannot always explain them, we feel we understand them; nothing we see of them, no matter how odd, is threatening. In 2003 Bown said that when she photographs people she is in that instant in love with them. What is evident from her earlier work is something rather different. Whether her subjects are schoolboys (56), soldiers (49), haymakers (38) or ponies (69) or even Brussels sprouts under snow (50), she is momentarily fascinated by them, in awe of them, even. Dingy, dirty and

bedraggled though they may be, they are all special. Strings of onions are as precious as the crown jewels (52); the familiar is revealed as extraordinary, irreplaceable.

In all the images that Bown found in the streets and the countryside, we are struck by the reticence of the camera. Even as she carefully marshals all the elements in her picture, Bown never becomes an element in it. Sometimes one or more people in a group will be aware of her presence, but there is no acknowledgment of communication or recognition (11, 54). Usually her subjects are not even looking in her direction; she has photographed some of the most expressive behinds in photography (12, 17, 20, 24, 28, 35, 44, 45, etc.). In the hands of Diane Arbus the Rolleiflex oppressed and frightened her subjects even though they couldn't see her sighting them through it. Arbus's gaze curdles the air her subjects breathe, emptying them of their humanity, whereas Bown's treatment of framing and distance allows the space between her and her subjects to seem theirs rather than hers. Though she was as diminutive in stature as Bown, Arbus intruded on her subjects and made a pictorial point of the intrusion. Infants on the end of her lens howl in terror; young couples look up, dwarfed and distorted. Bown believes that a photographer should be neither seen nor heard. Rather than orchestrate her moment she waited for it.

Both Cartier-Bresson and Bown are supremely uninterested in photographic technology. Having learnt how to make satisfactory images with one camera, they each remained with that camera, accepting its limitations as imposing a necessary discipline upon their image-making, as well as allowing them to concentrate on the realisation of the subject. Colour would have destroyed one important element of their work – the dramatisation of the subject by the use of light, in both cases available light. It goes without saying that Bown never uses flash. What this means in effect is that she has no truck with the generation of glamour images, and hence her portraits seem truer than those of other photographers. The '60s saw the rise of celebrity culture, and the gradual waning of Bown's passion for art photography. The earlier Bown's attitude to celebrity had been like Cartier-Bresson's. Rather than photograph the celebrity she photographed the public reacting to celebrity. She was happier chronicling decisive moments in the lives of ordinary people than making headshots of popstars but there was no longer a market for images of Grimsby dockers cycling to work (93) or nannies at the Serpentine (72) or families at the seaside (25).

When Jane Bown laid down her Rolleiflex and swapped it for a 35mm camera in 1963 she was capitulating to a massive shift in taste and cultural focus. She has said several times since that it was the *Observer* that made her into a portrait photographer and there can be no questioning her success in that genre. Occasionally she took the Rolleiflex on assignment, giving us something as remarkable as her picture of the Torrey Canyon disaster of March, 1967 (70). It was a remarkable partnership and I for one am sorry that it had to end.

Germaine Greer

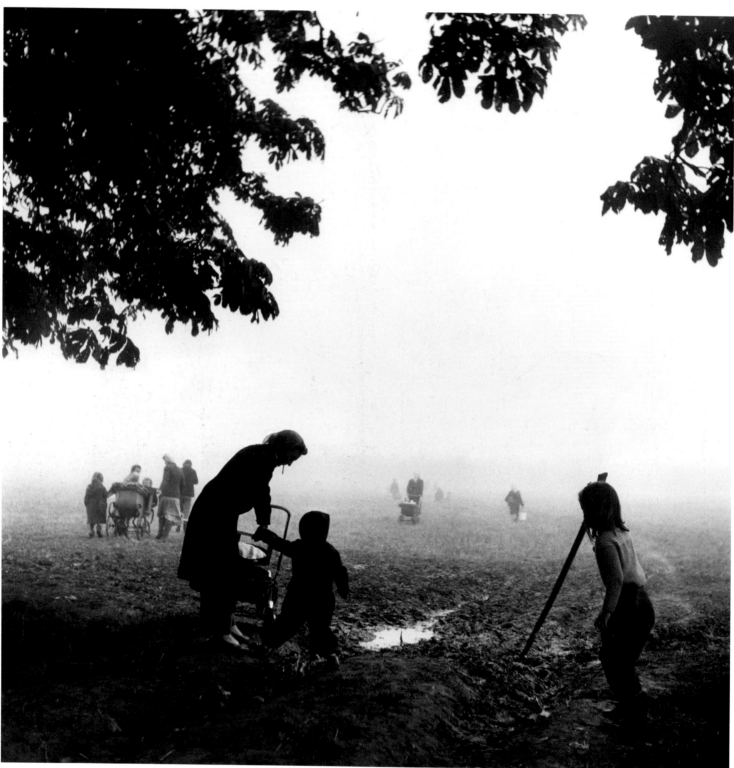

2

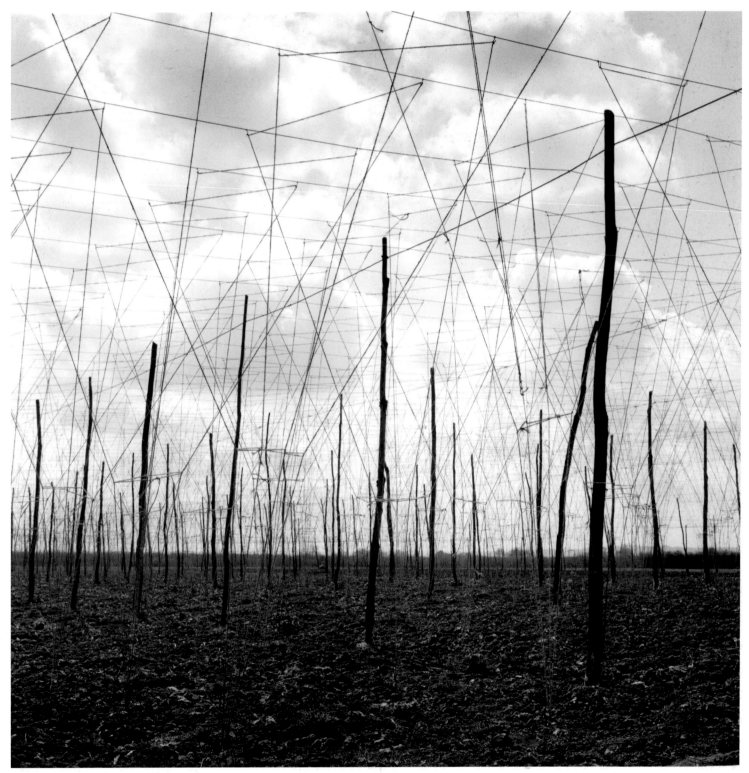

3

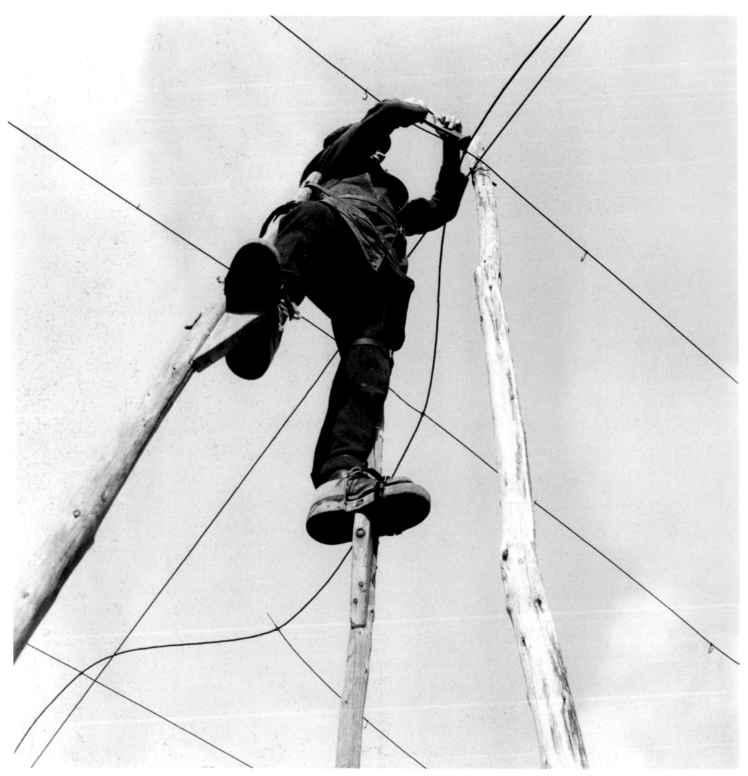

4

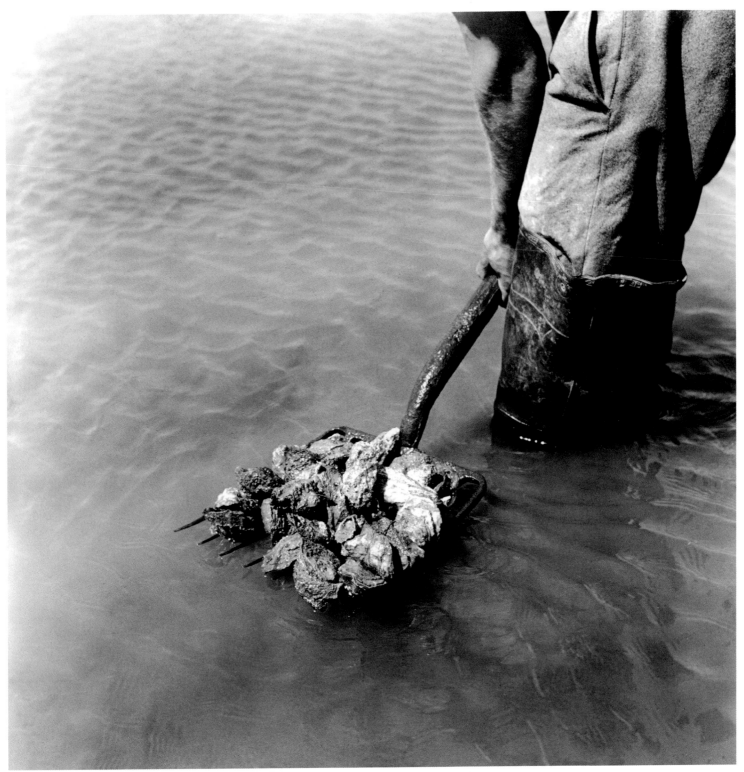

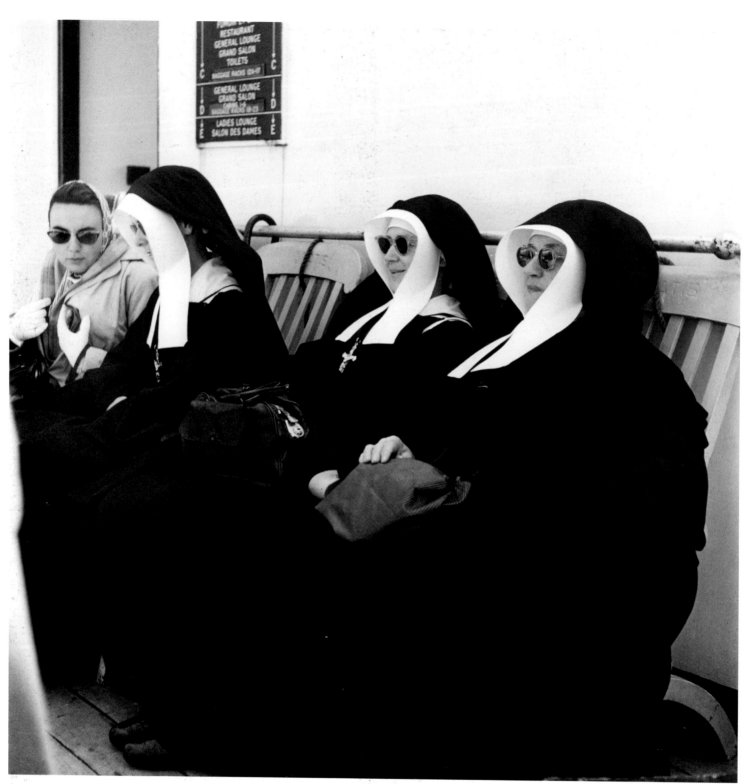

6

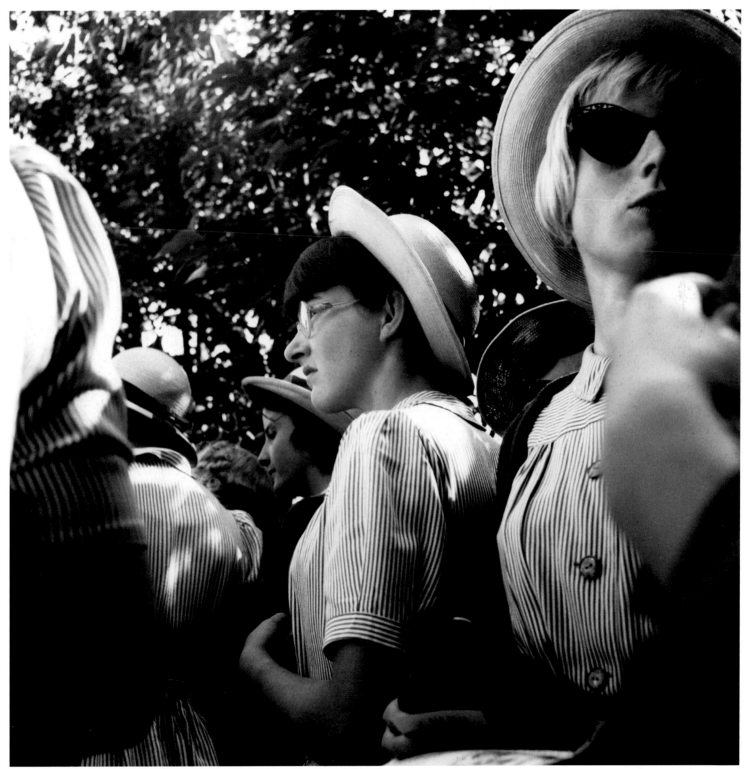

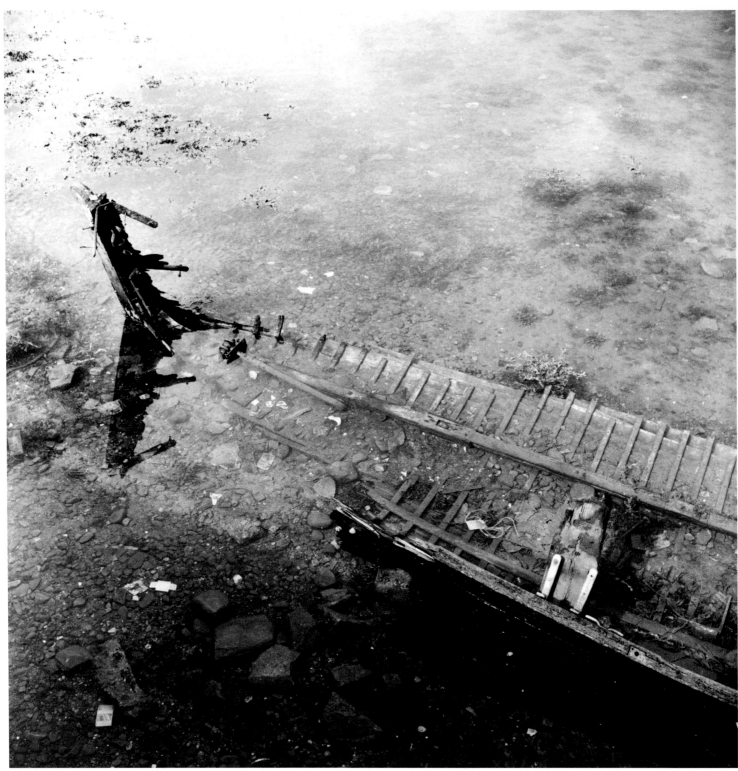

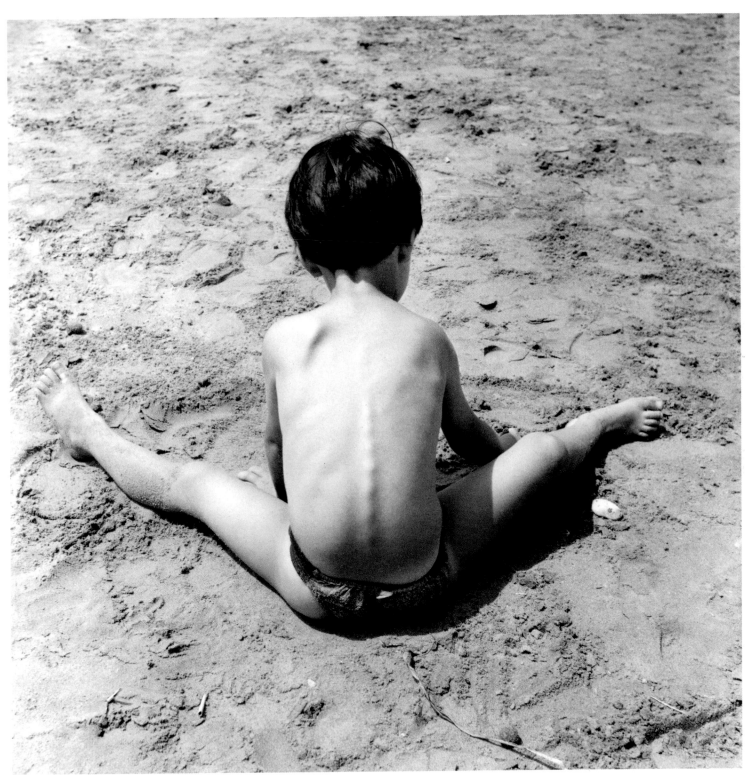

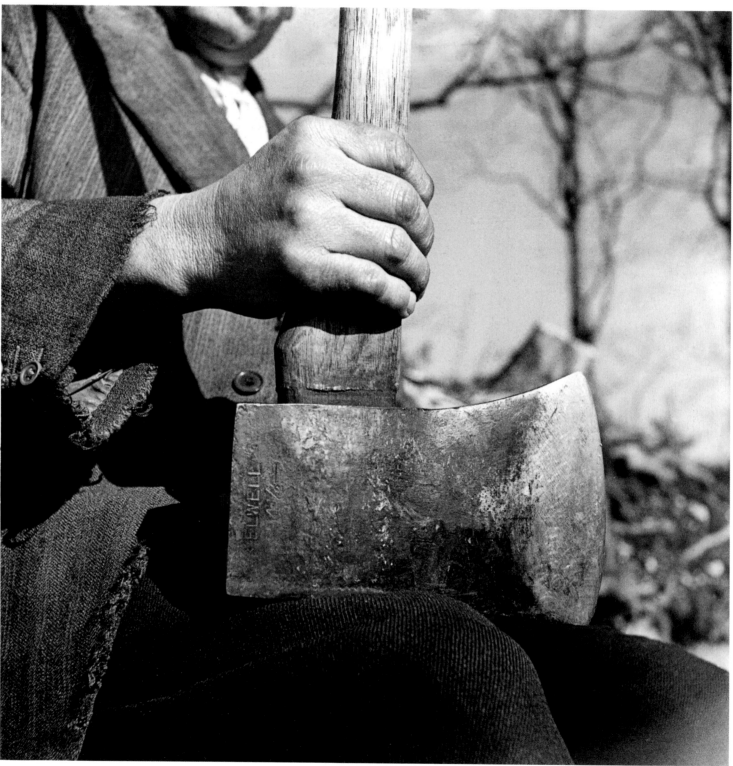

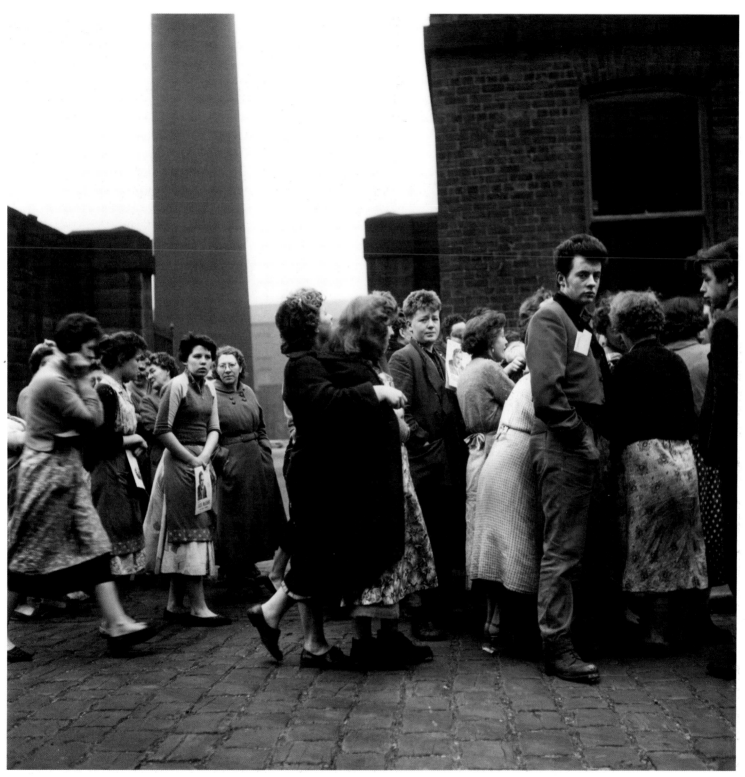

Some people take pictures, I find them

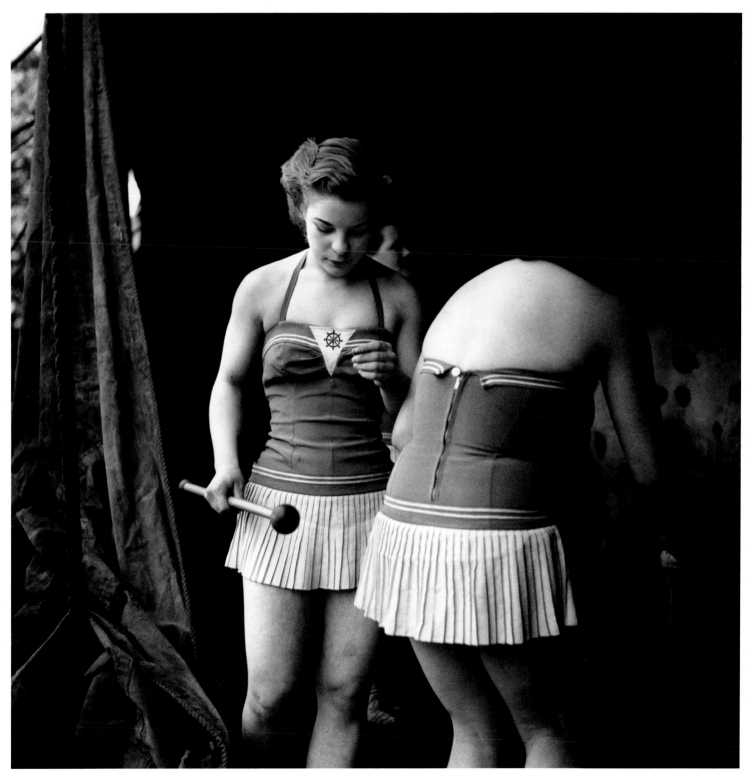

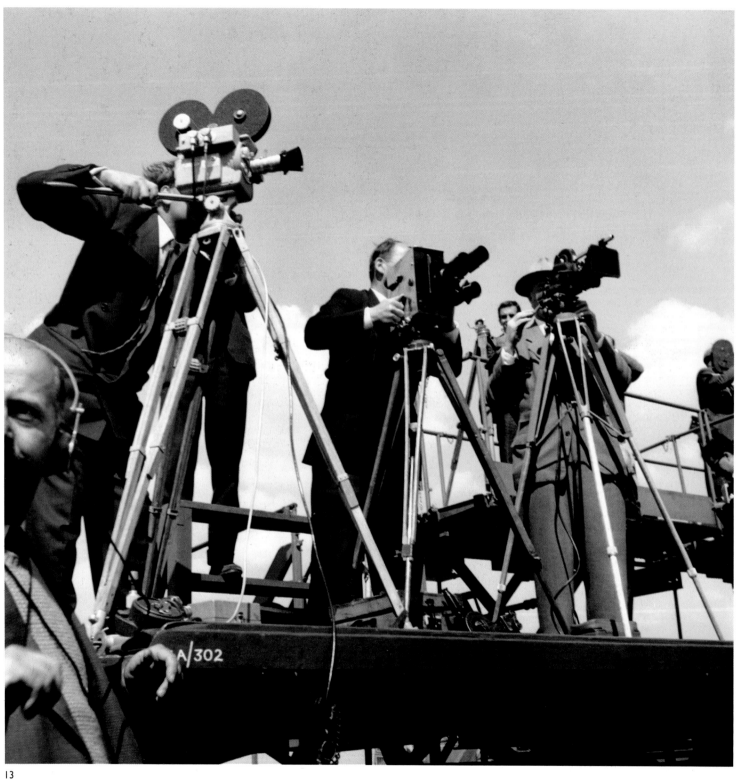

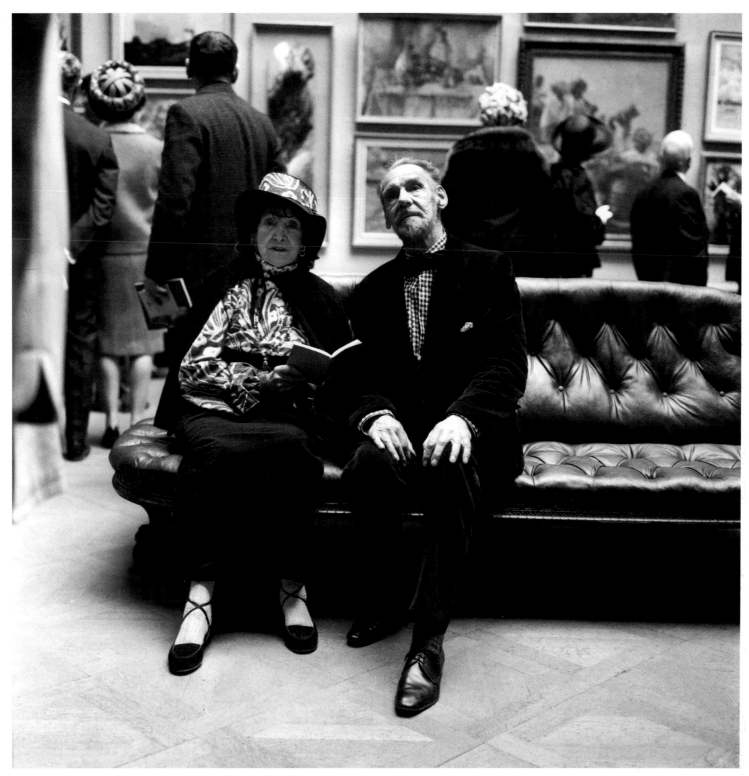

14

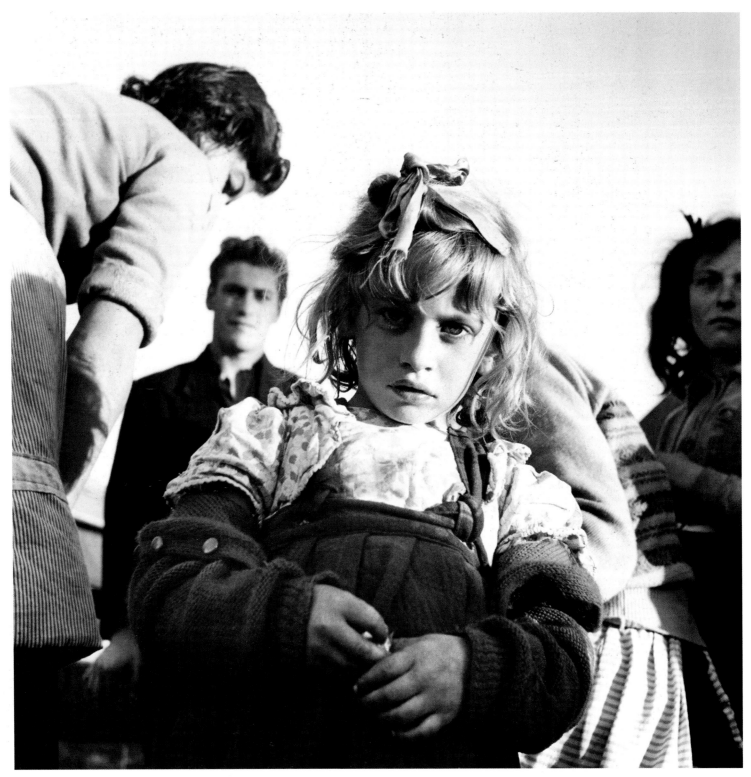

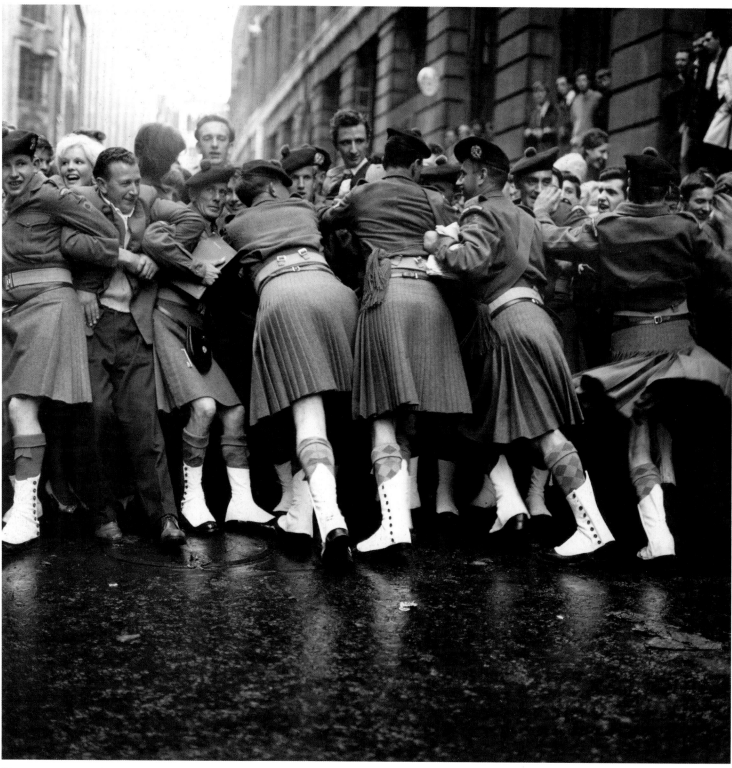

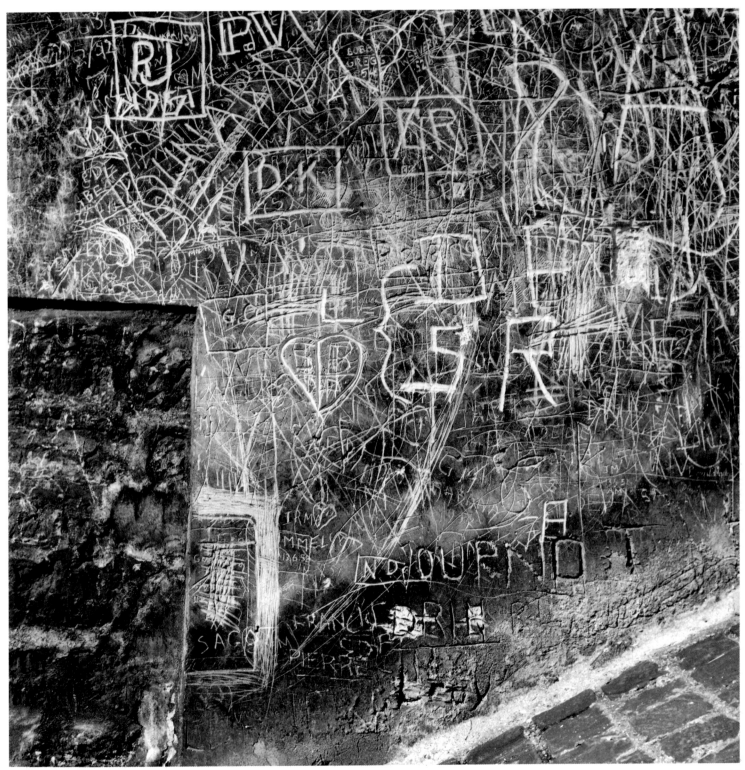

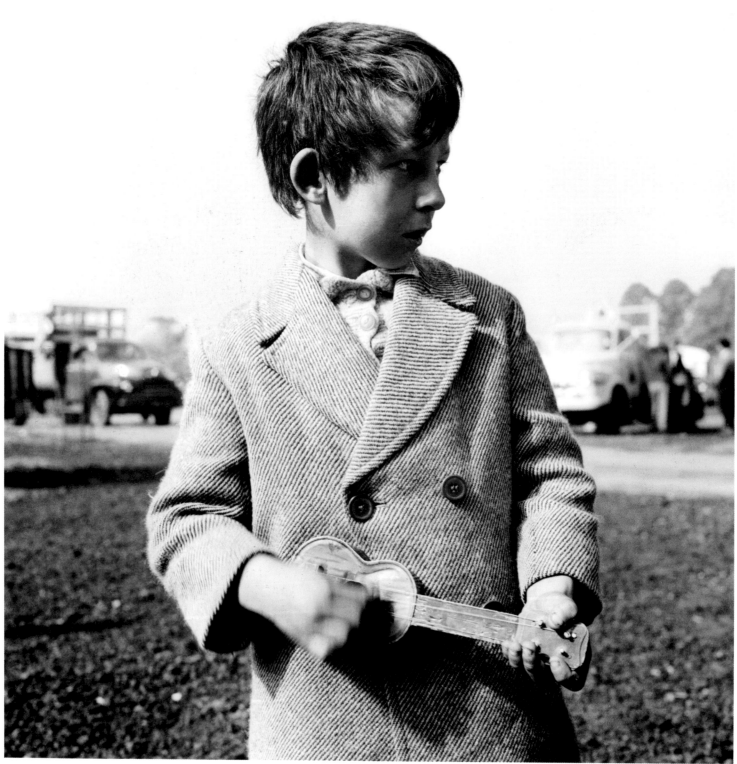

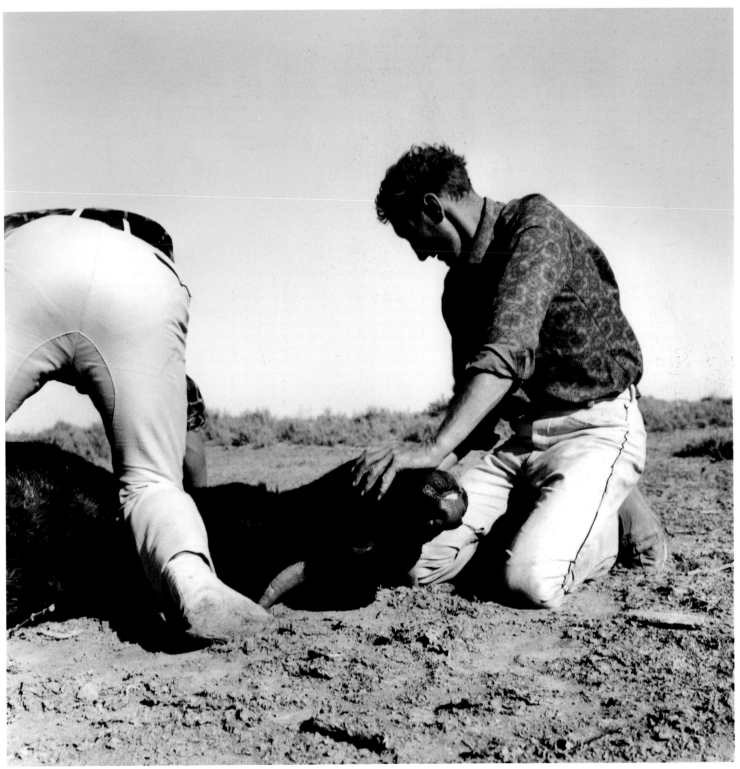

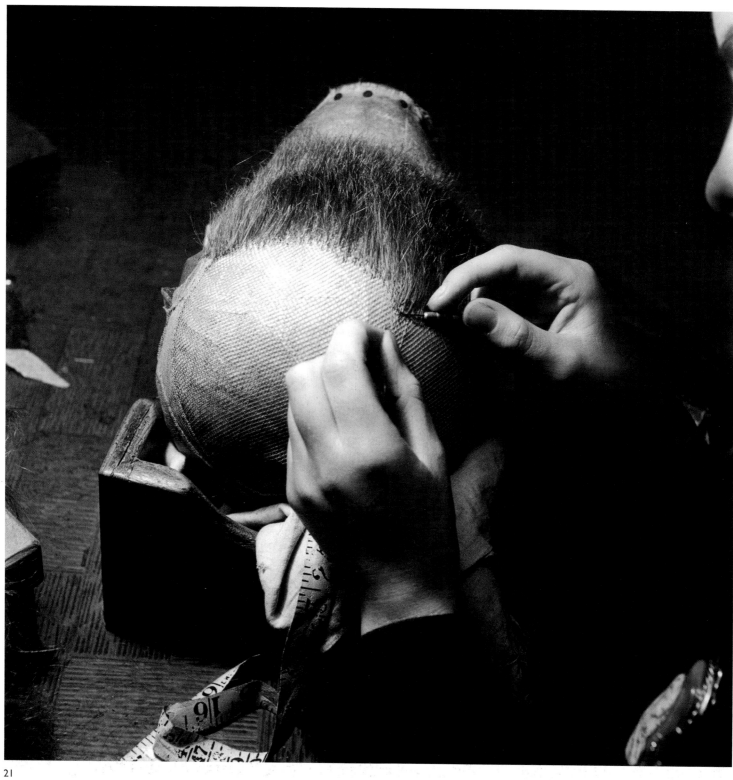

21

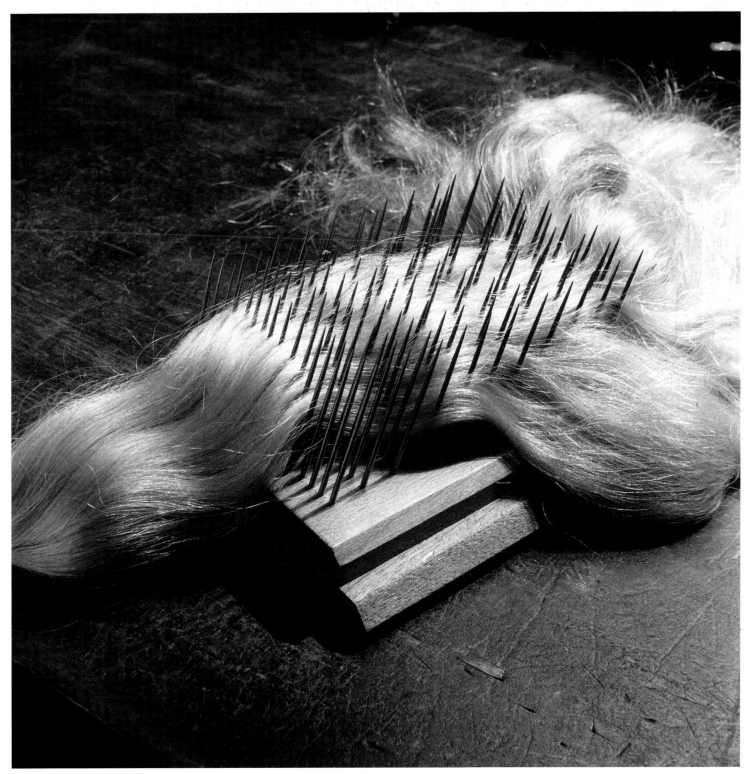

I love train stations
and airports, places with
lots of people where
I can blend into the crowd
and work unobserved

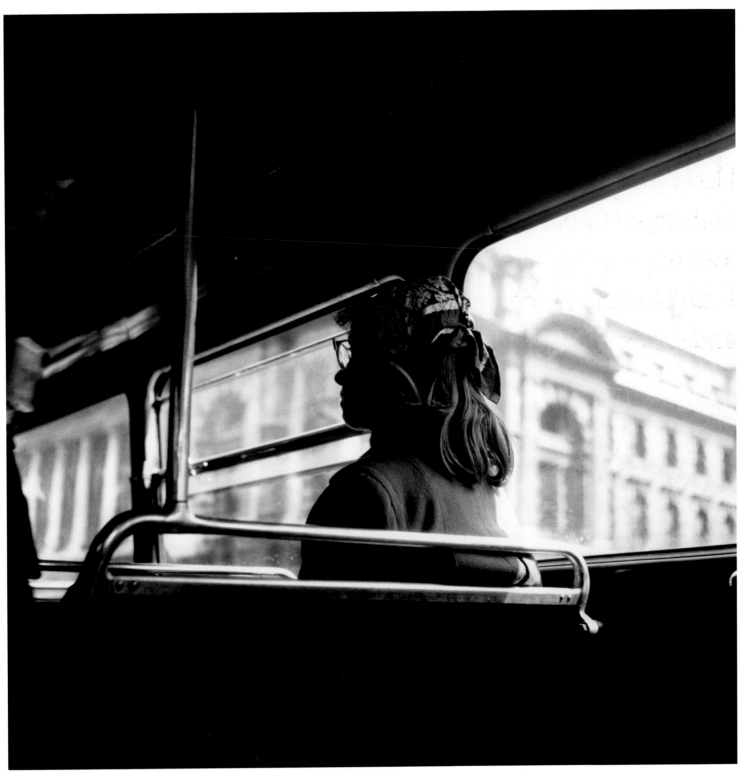

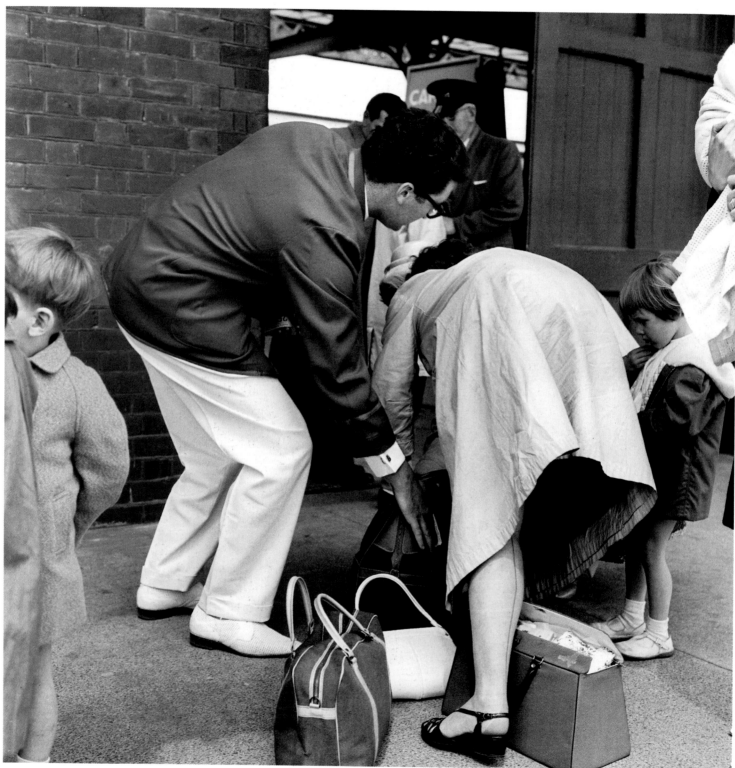

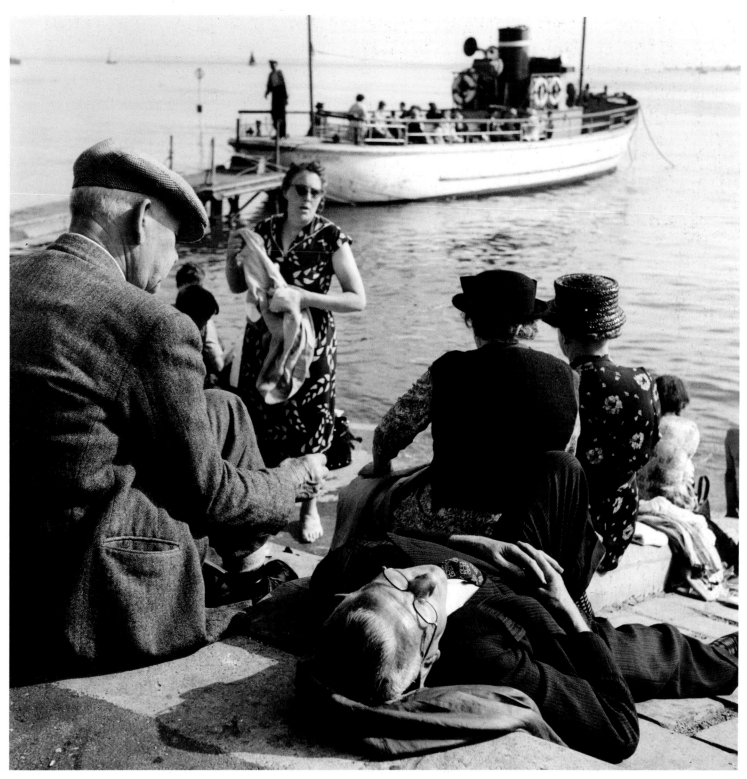

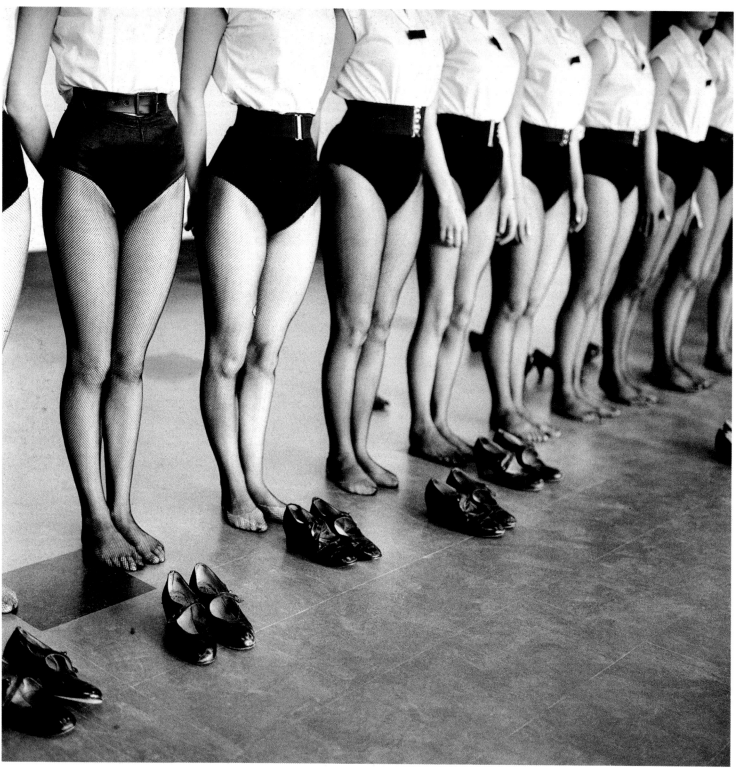

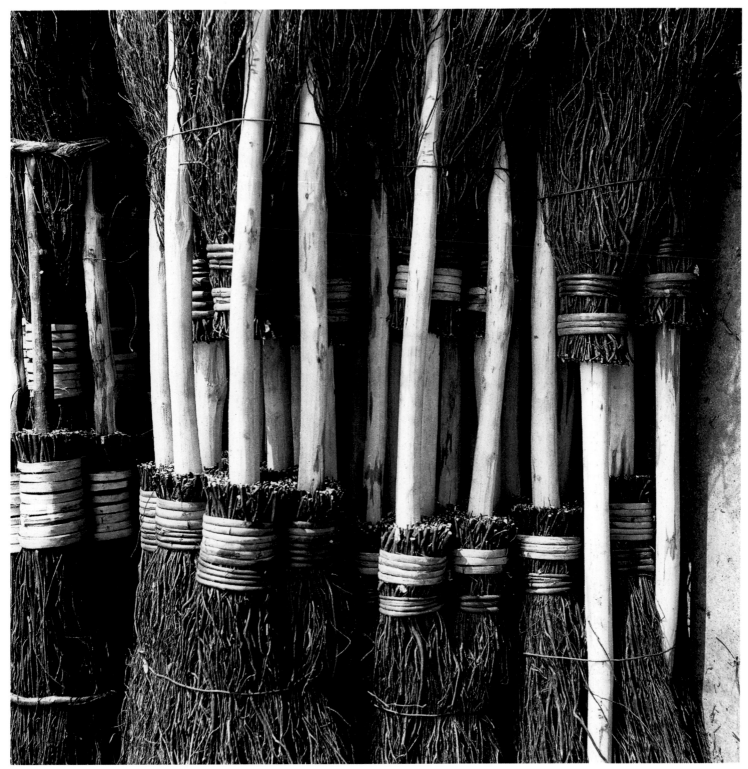

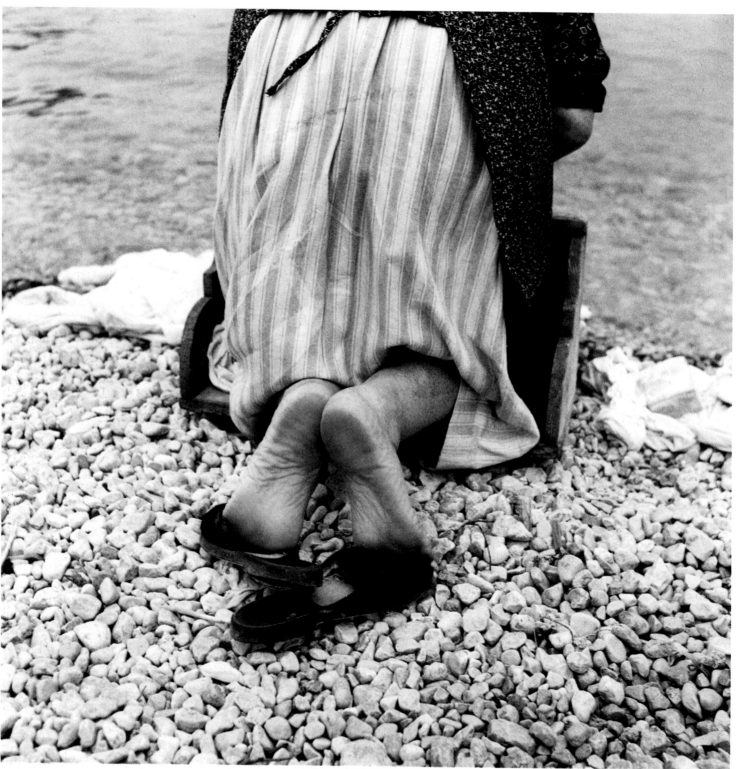

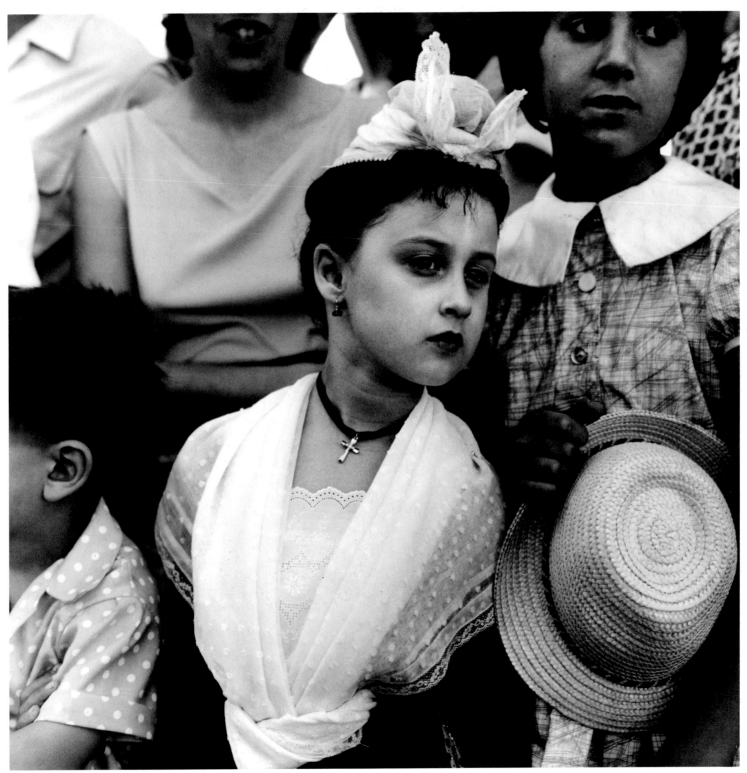

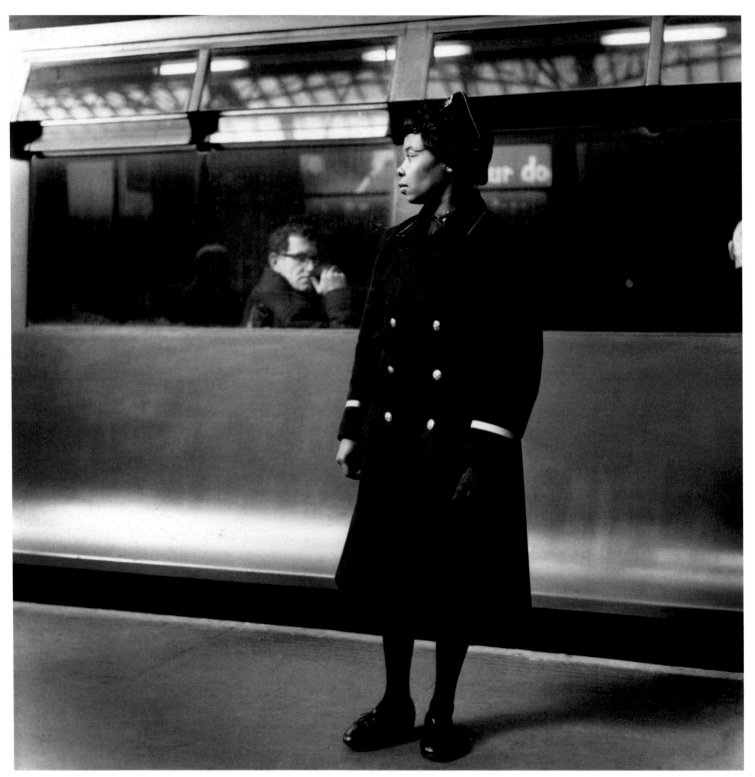

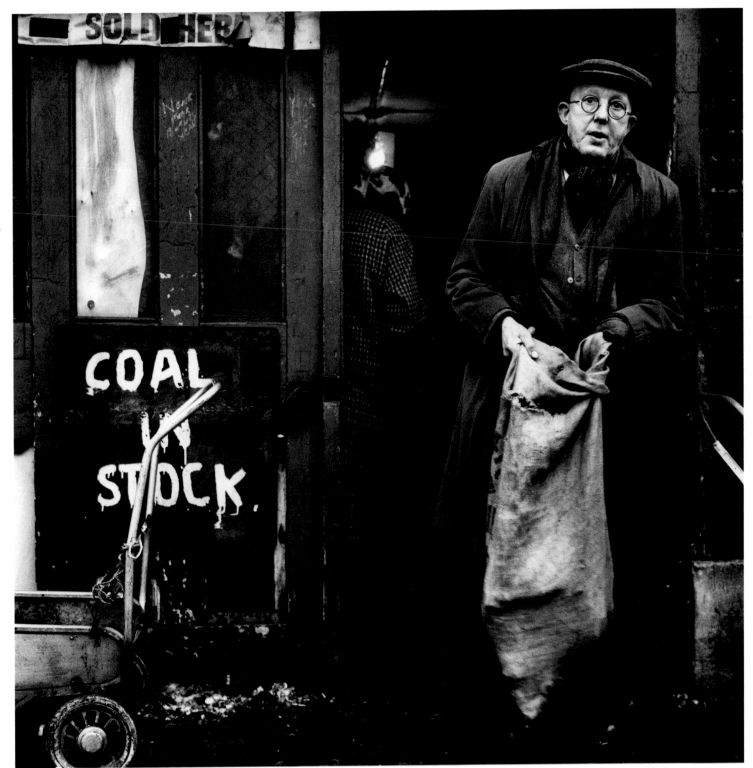

I was obsessed with
textures and patterns –
hair, cloth, the grain
of a piece of timber,
the print of a fabric

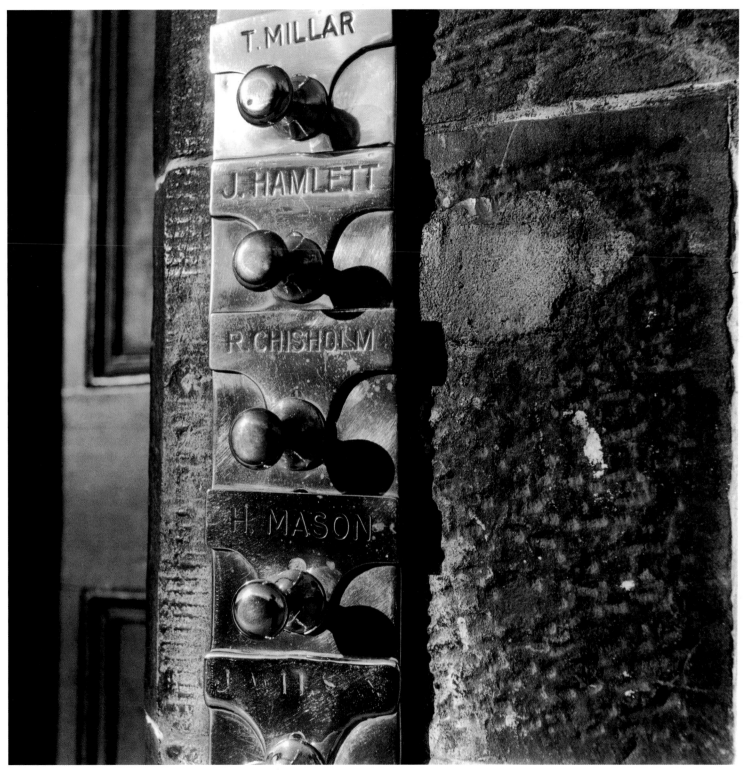

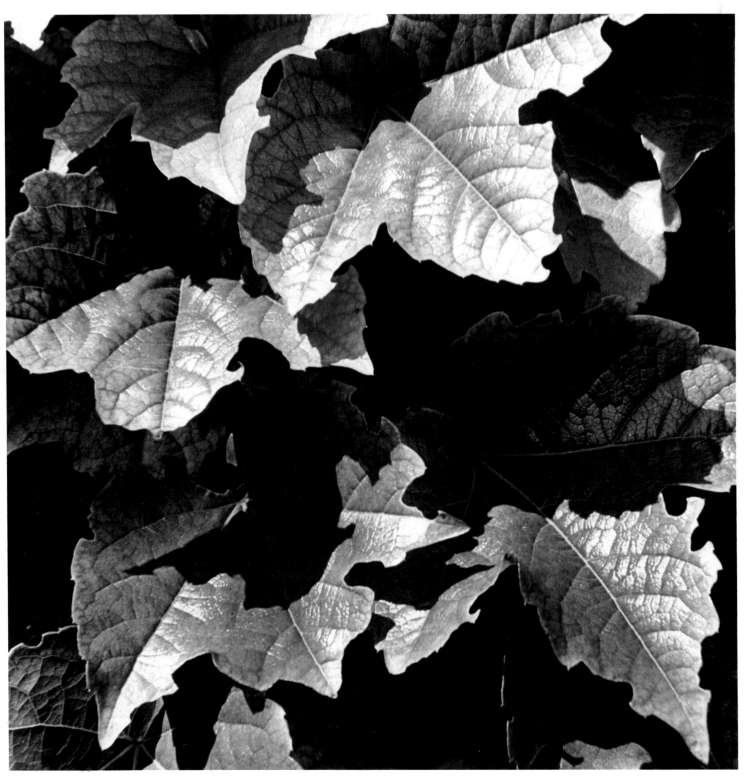

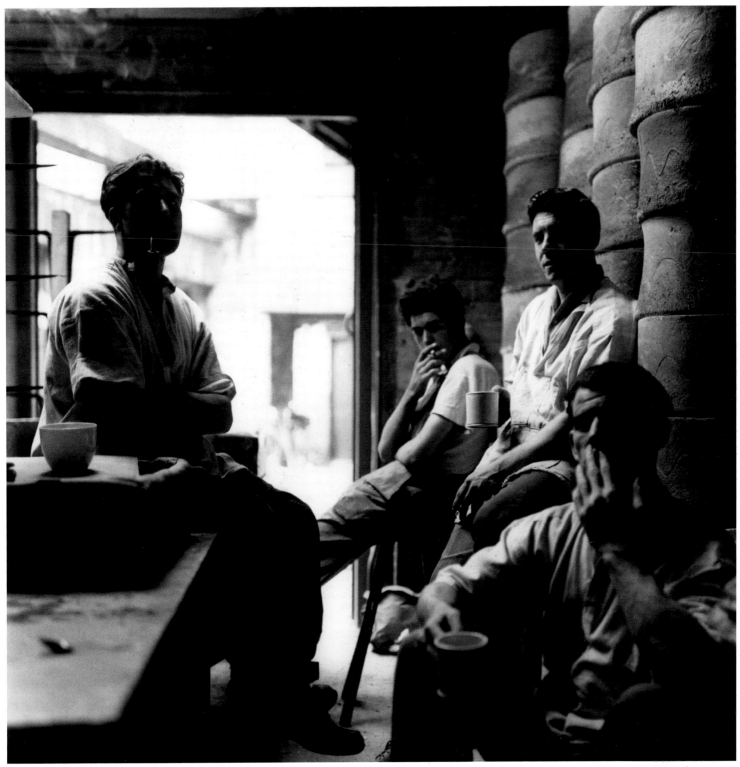

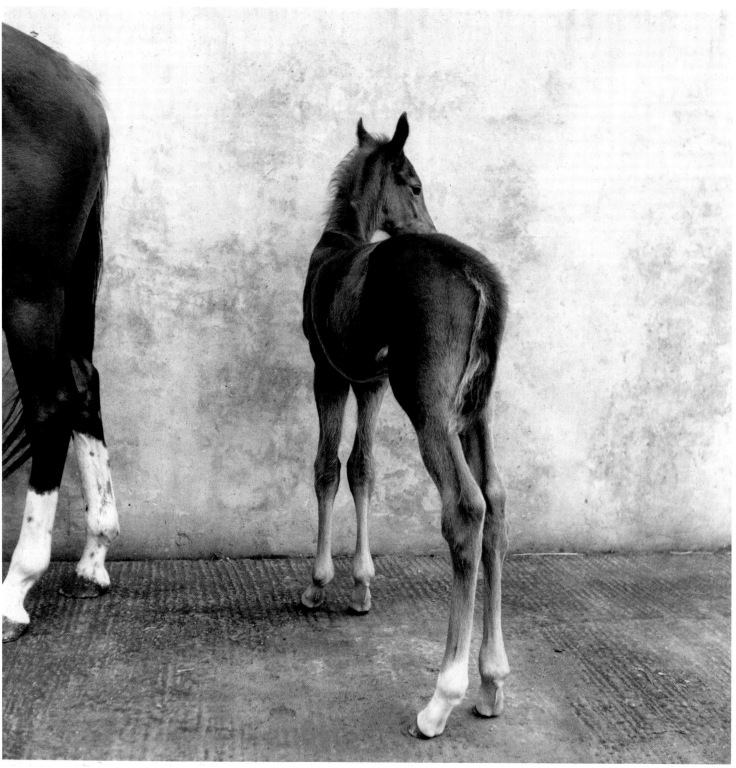

35

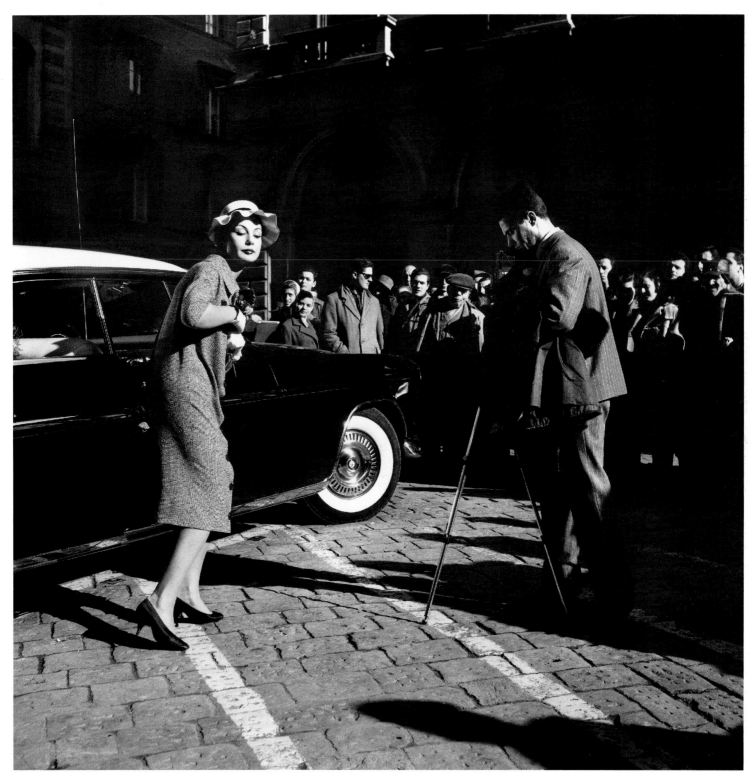

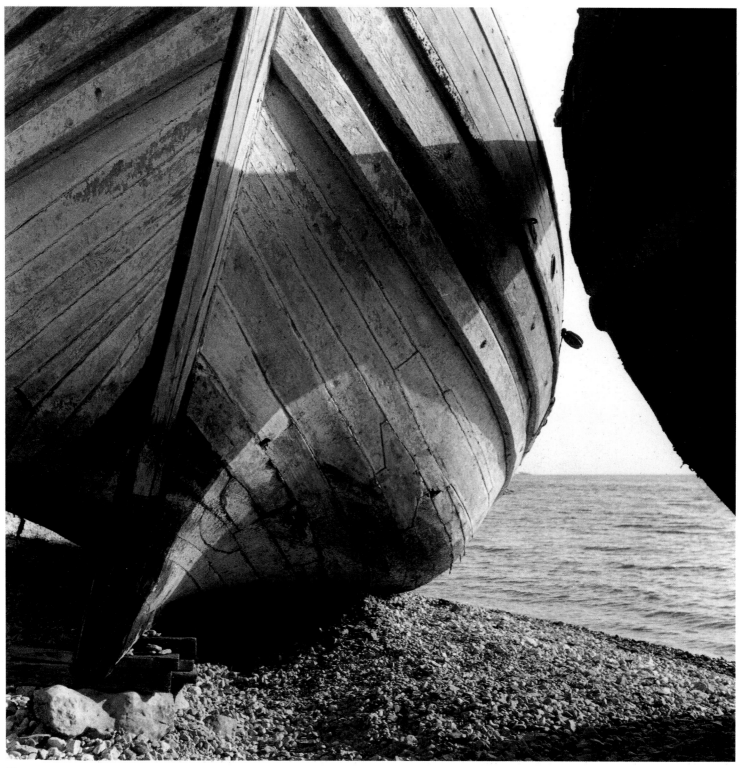

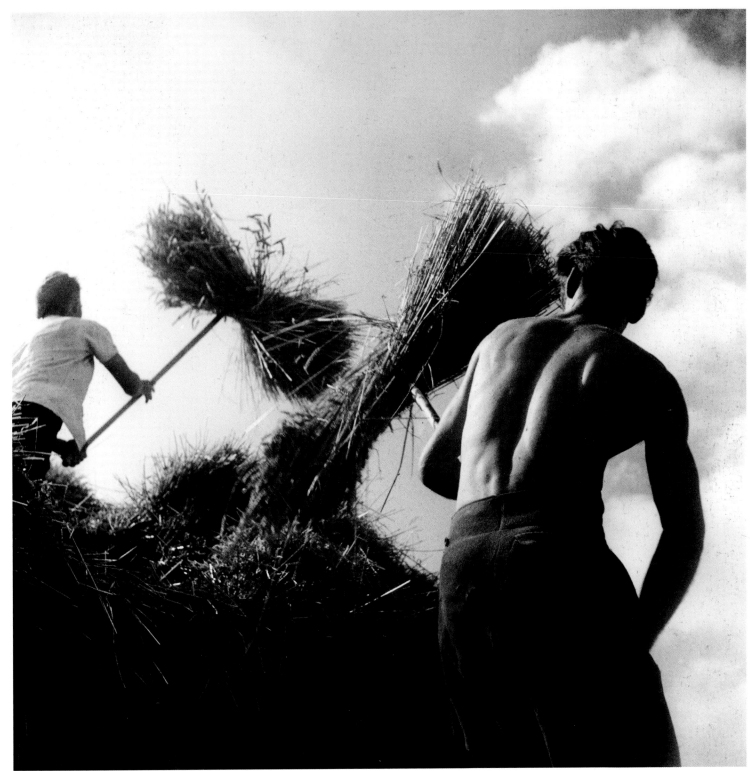

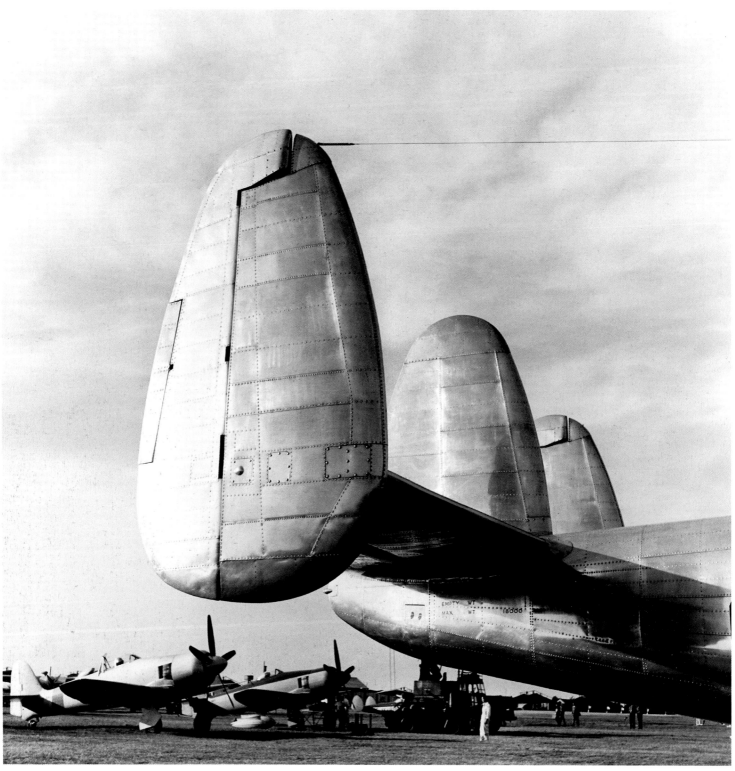

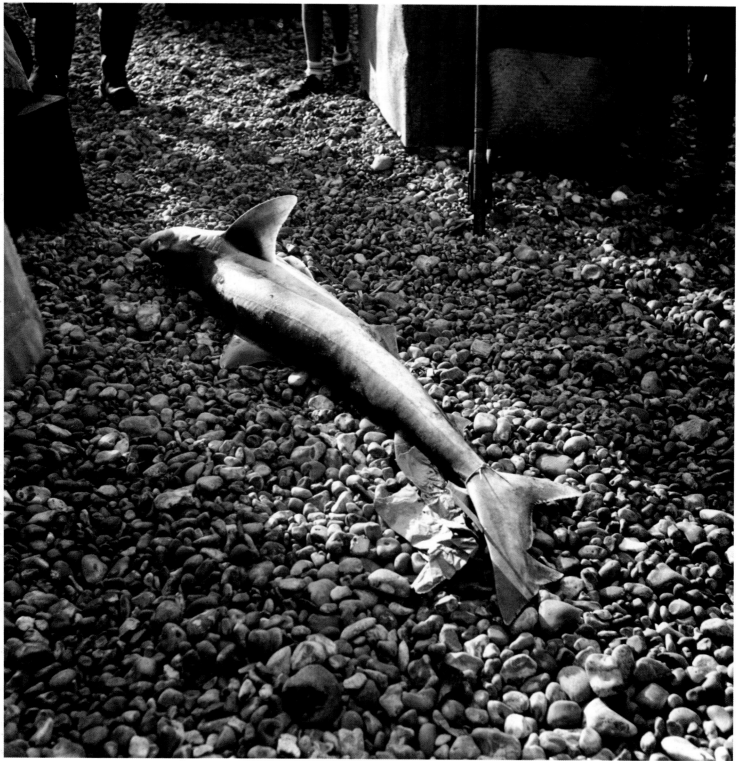

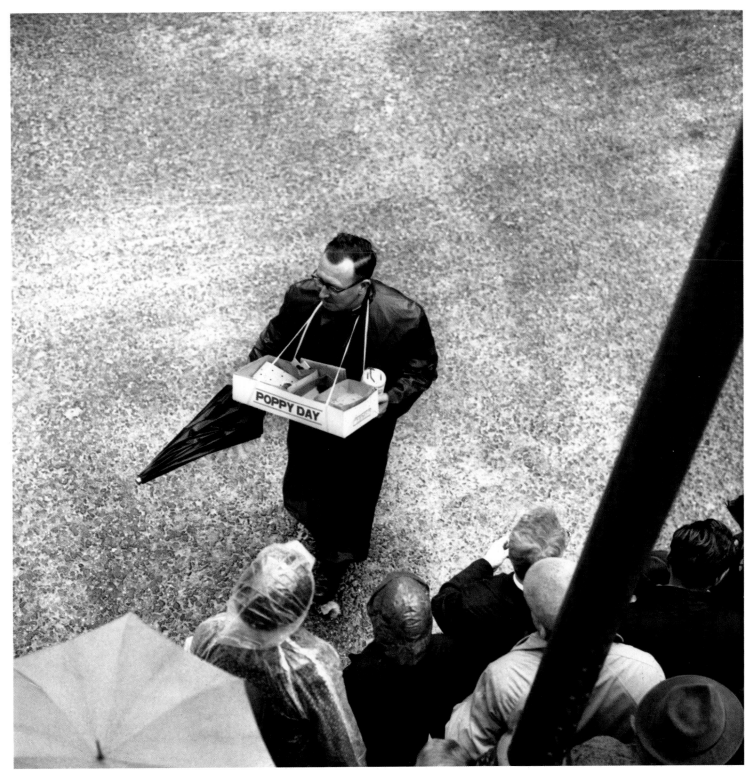

I'm a one-shot
photographer, I work
quickly and hate fuss,
always have done

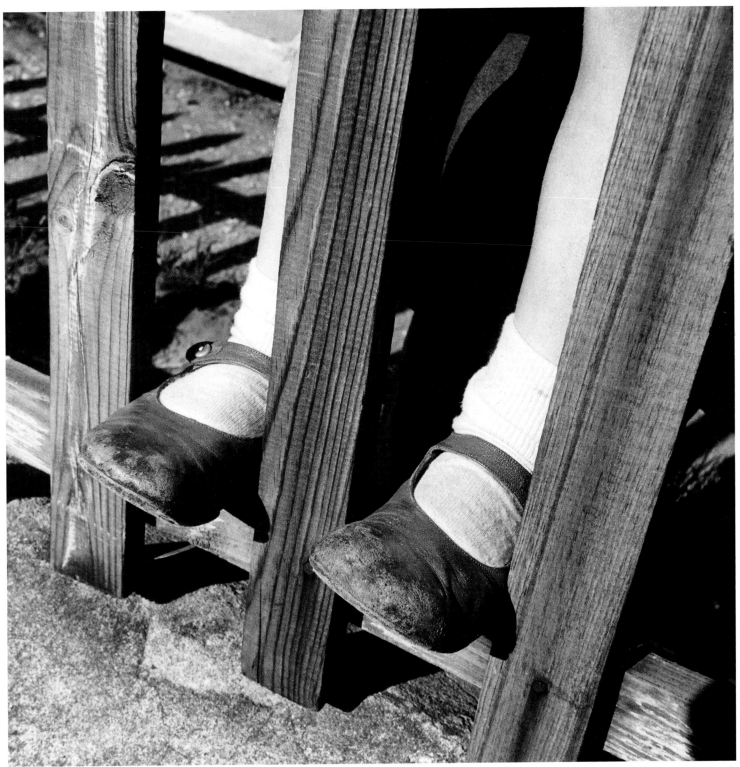

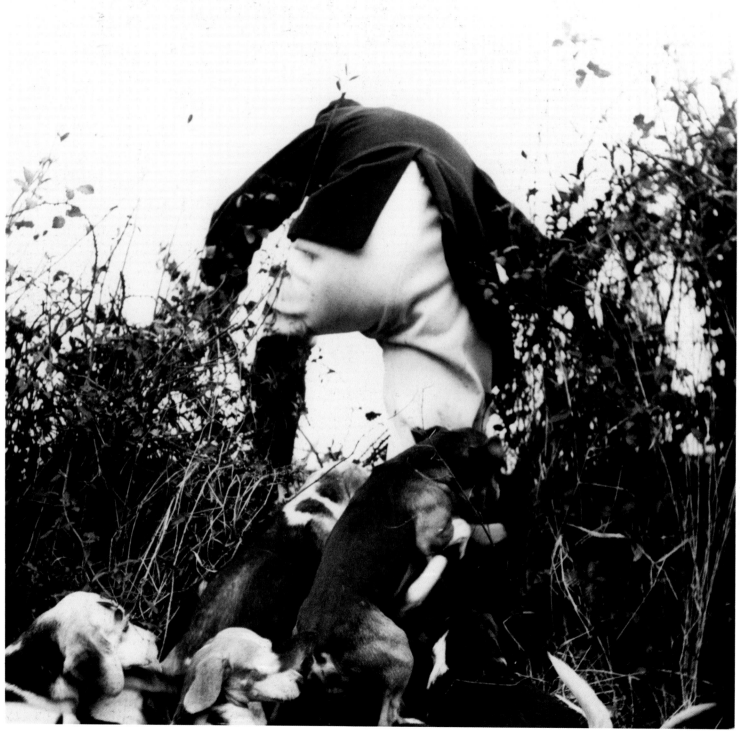

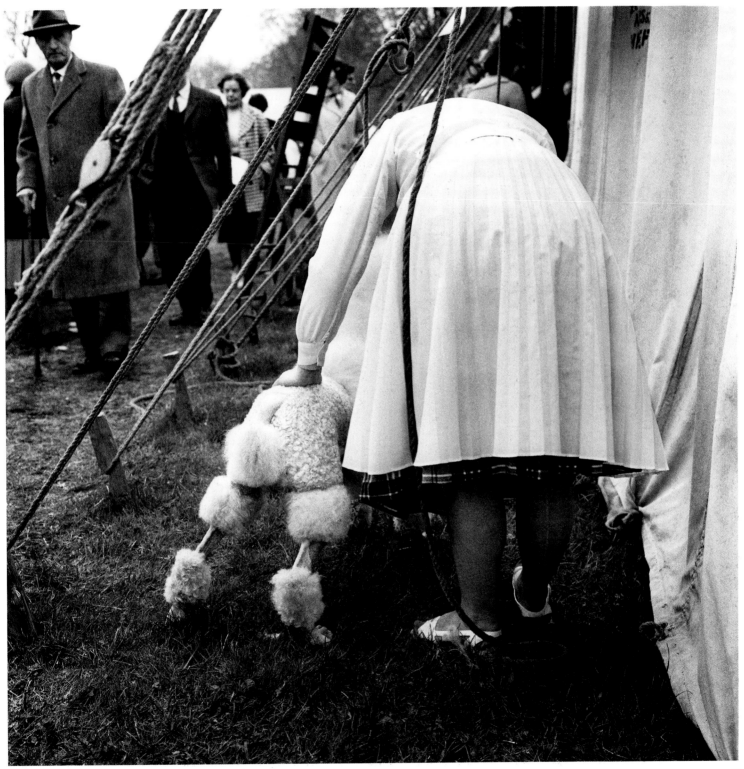

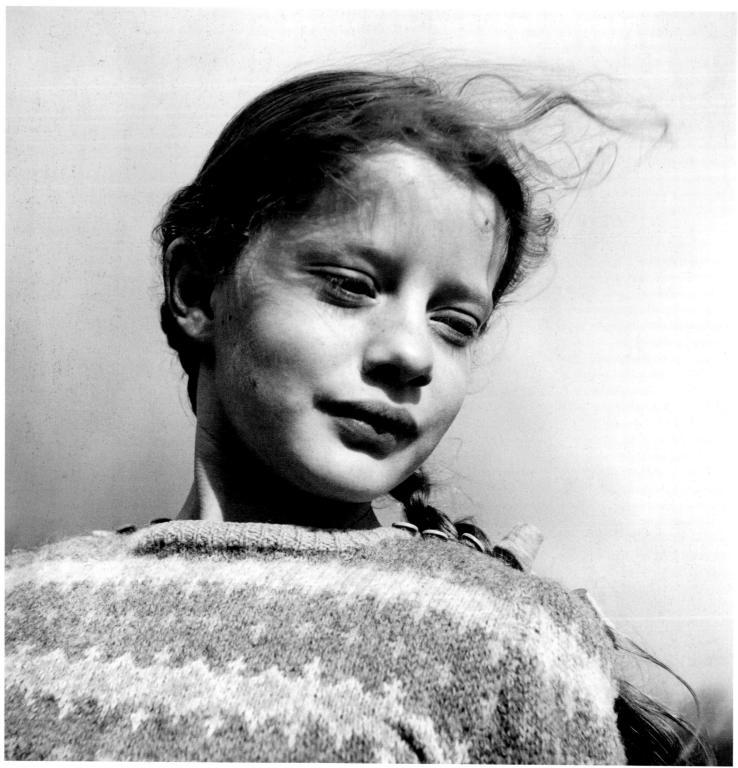

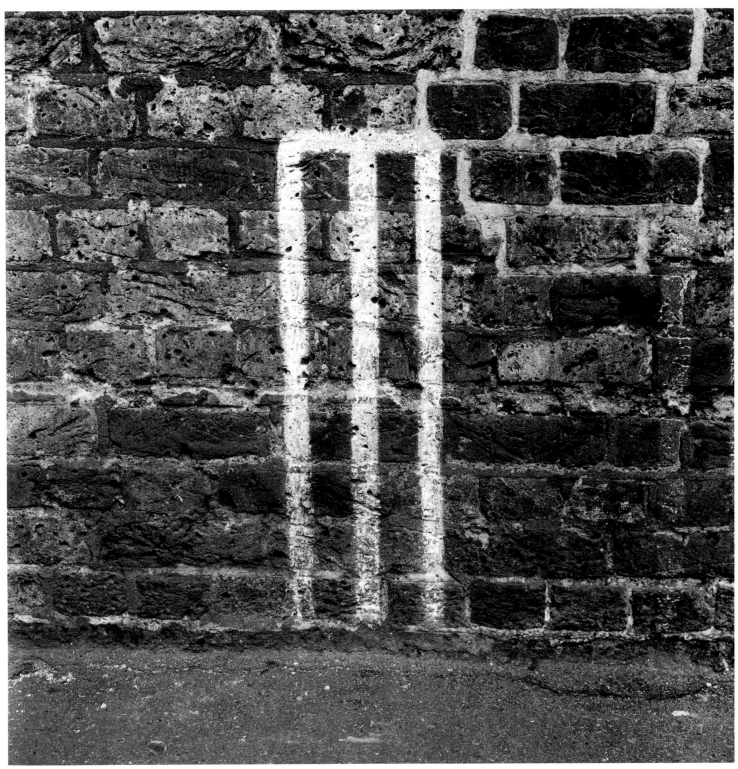

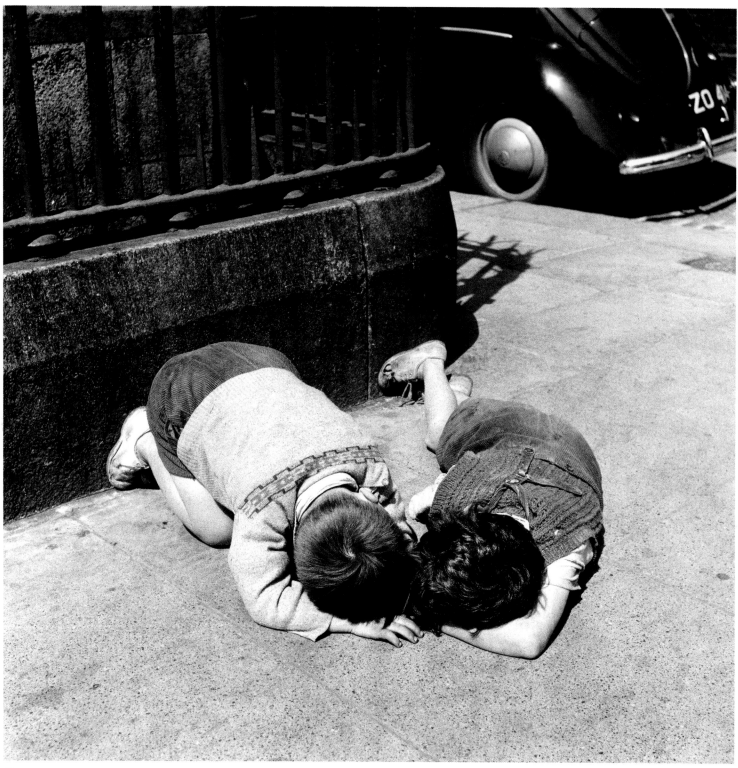

48

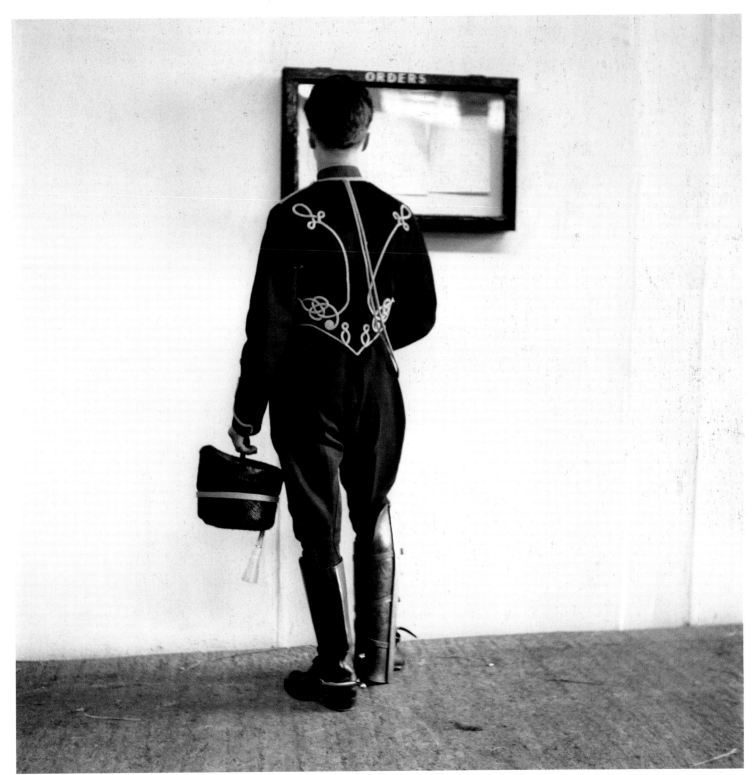

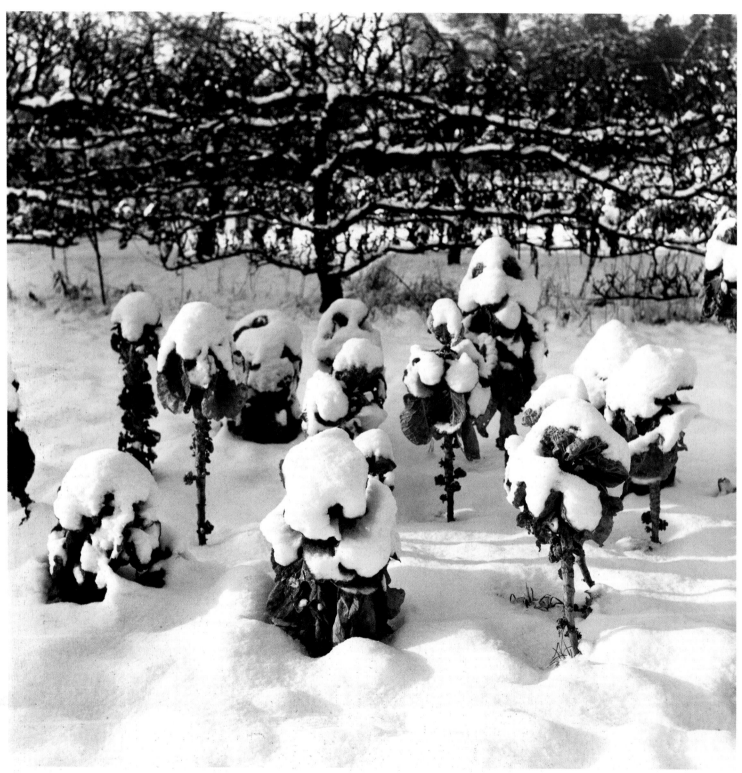

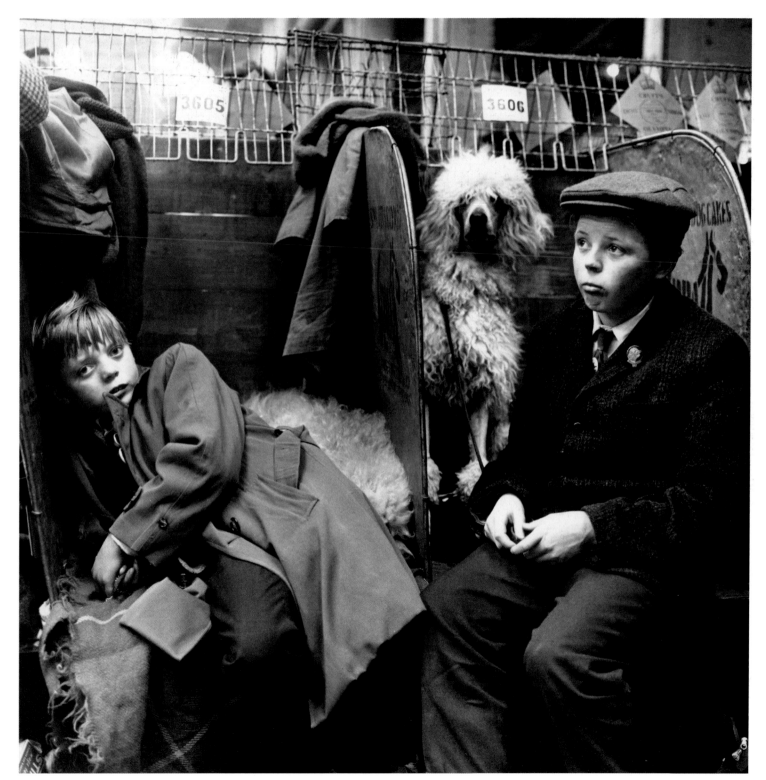

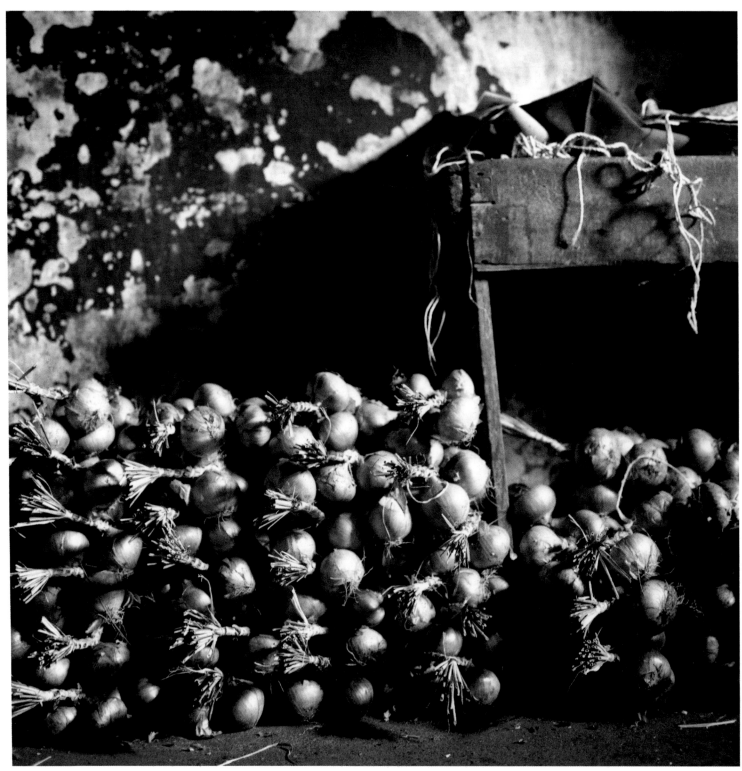

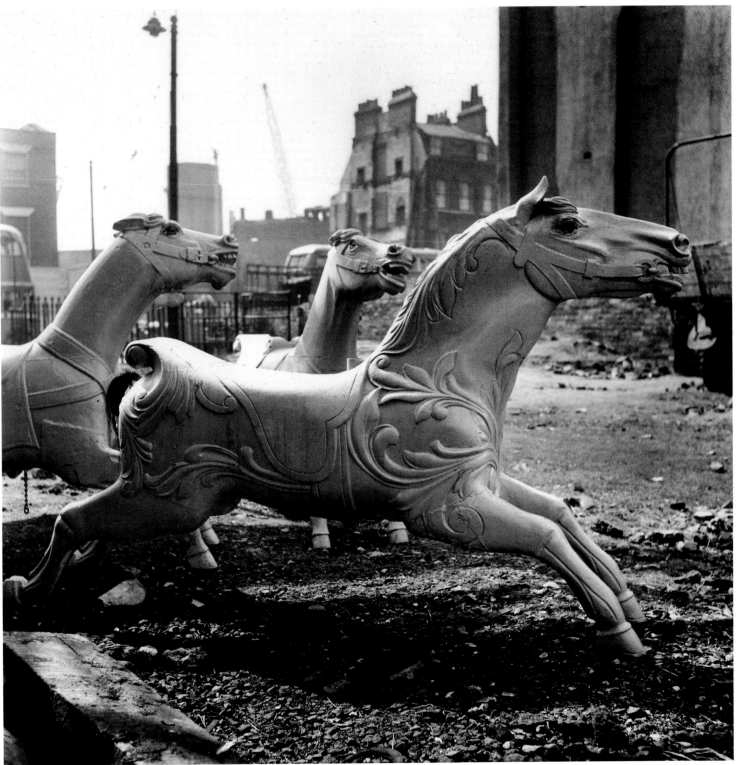

I honestly think that
all my best shots
were taken on holiday

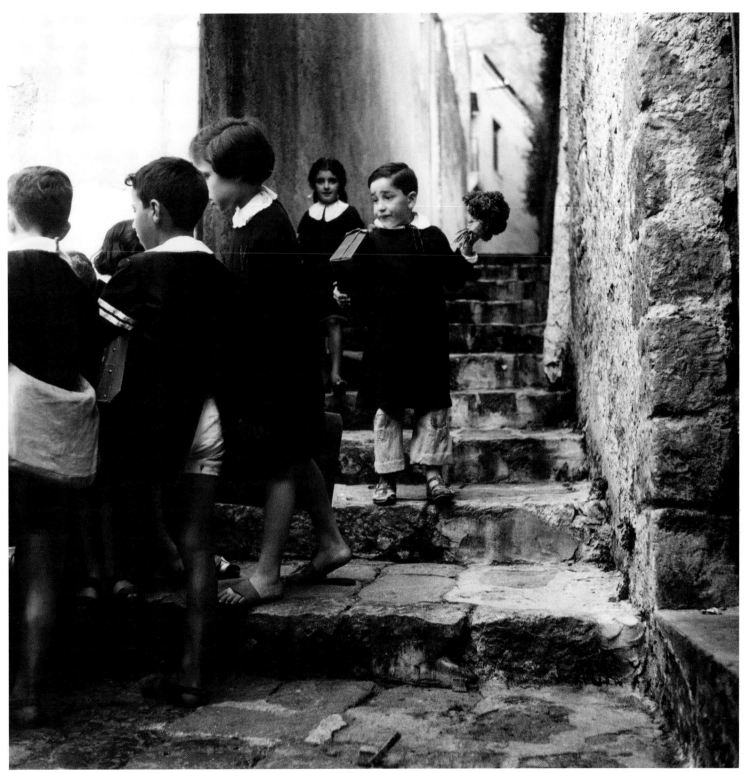

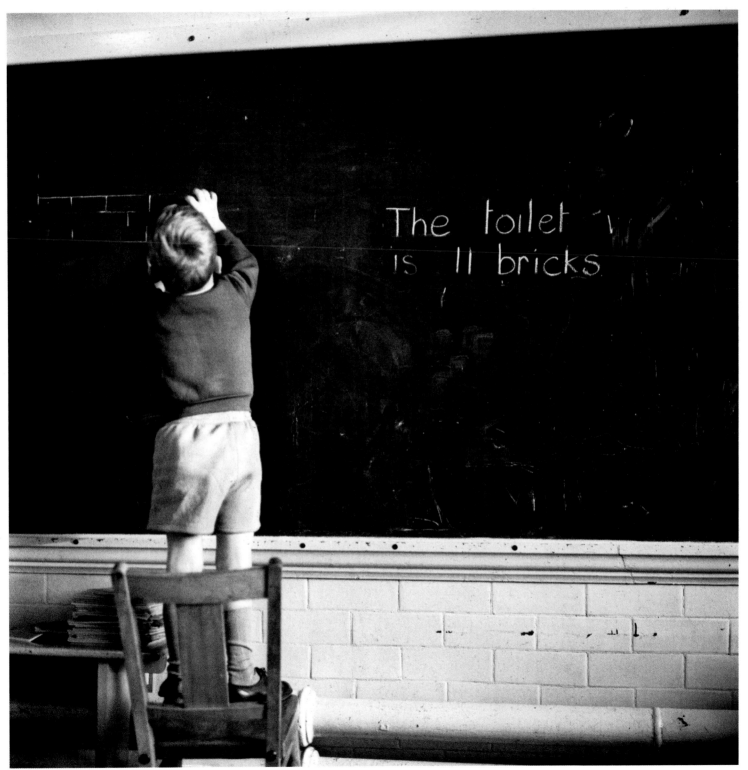

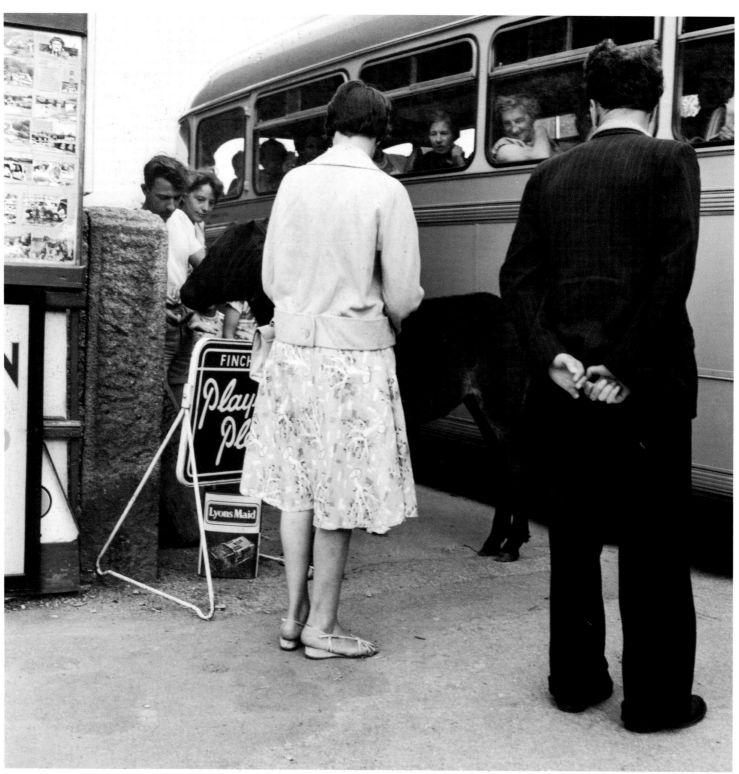

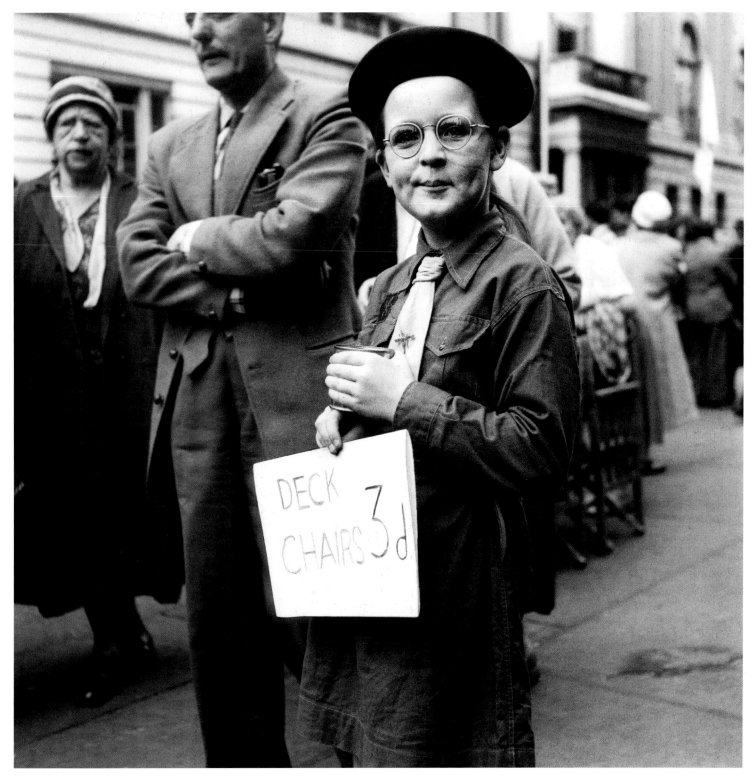

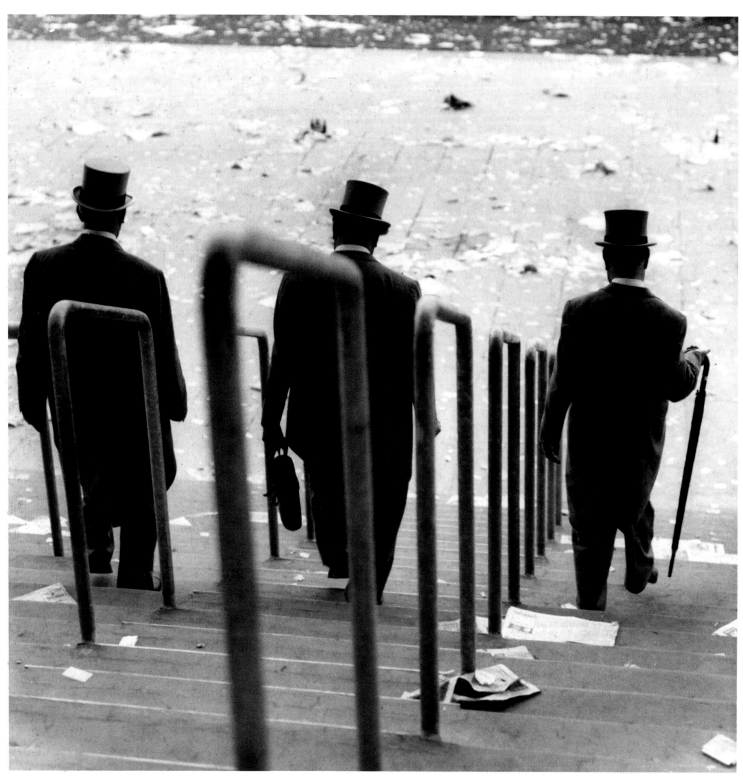

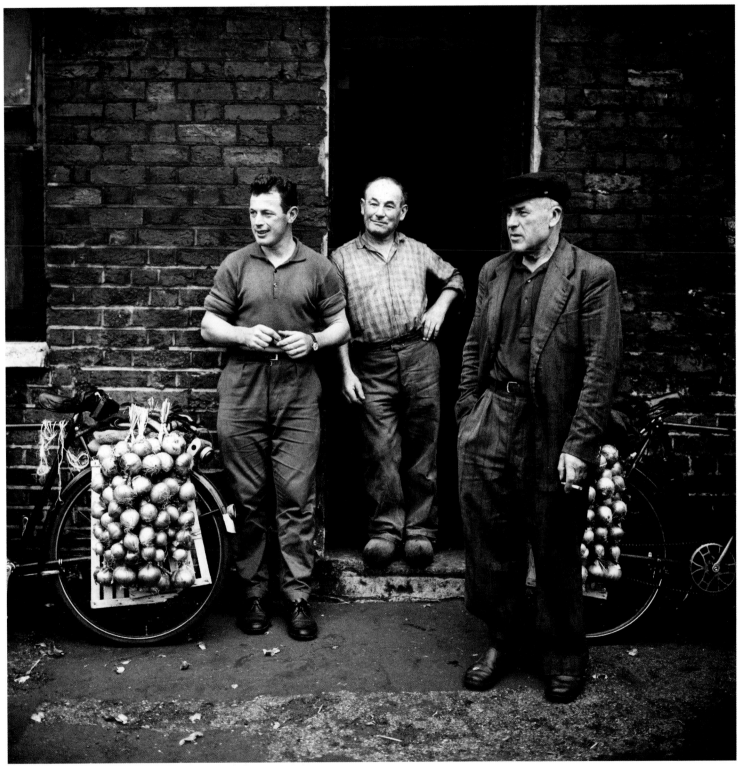

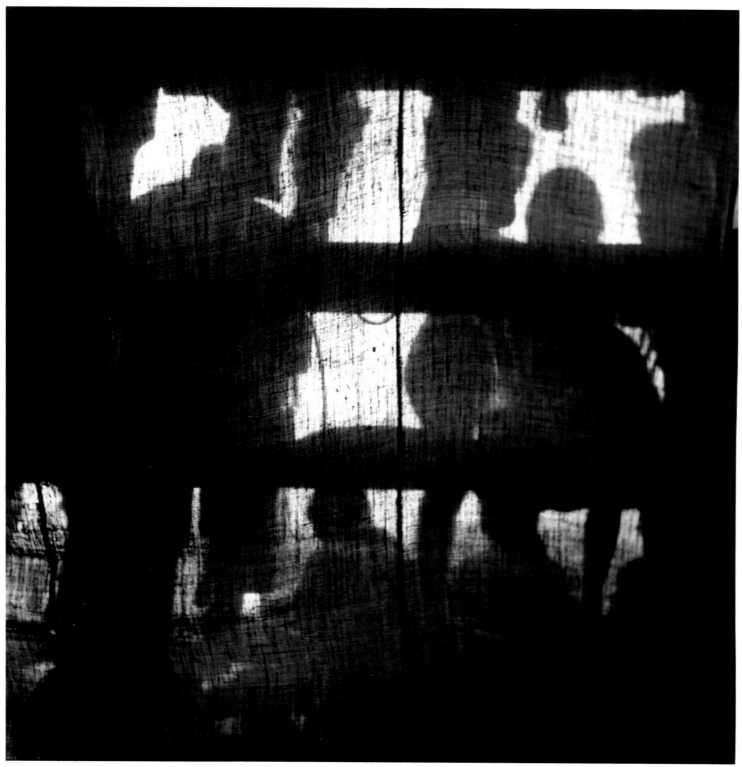

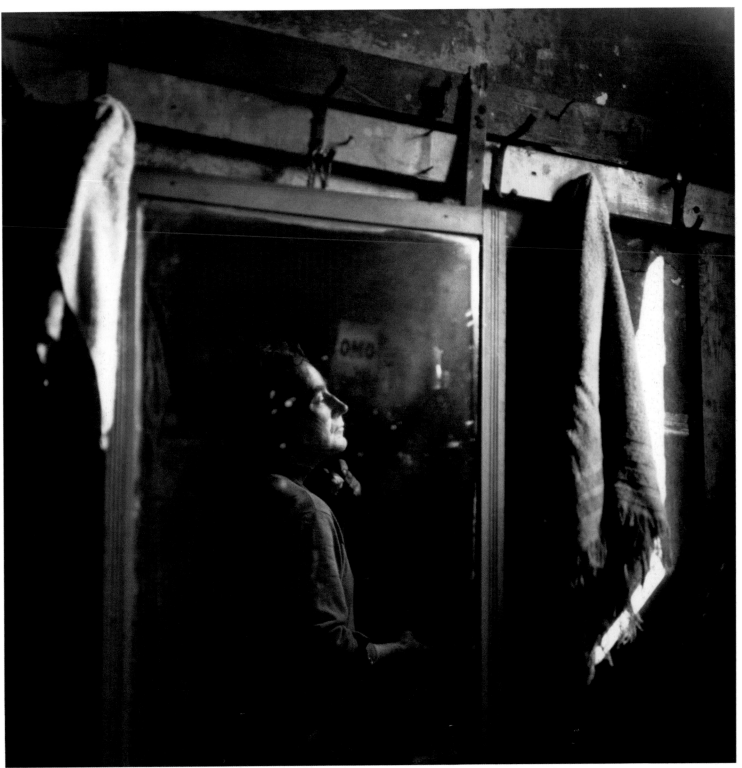

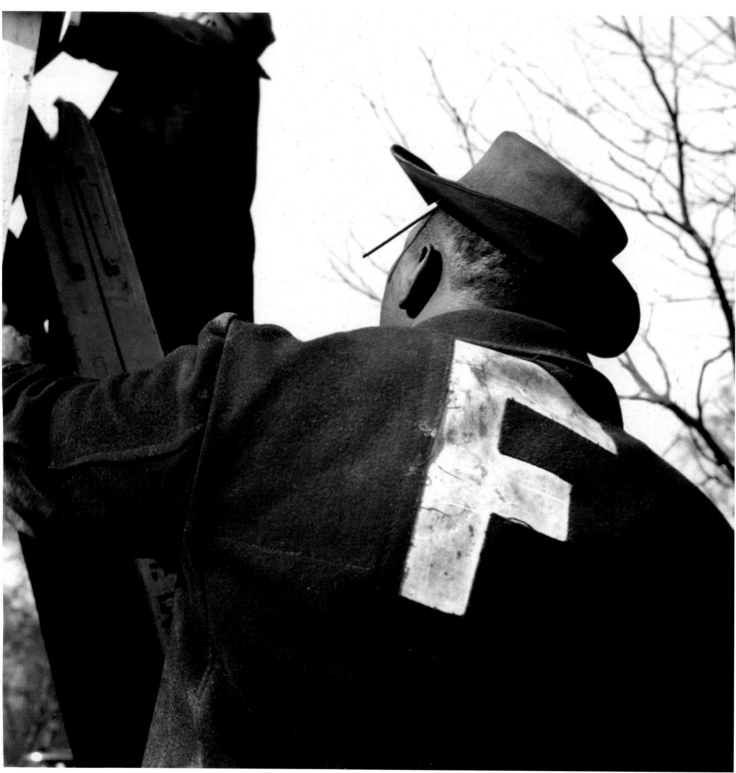

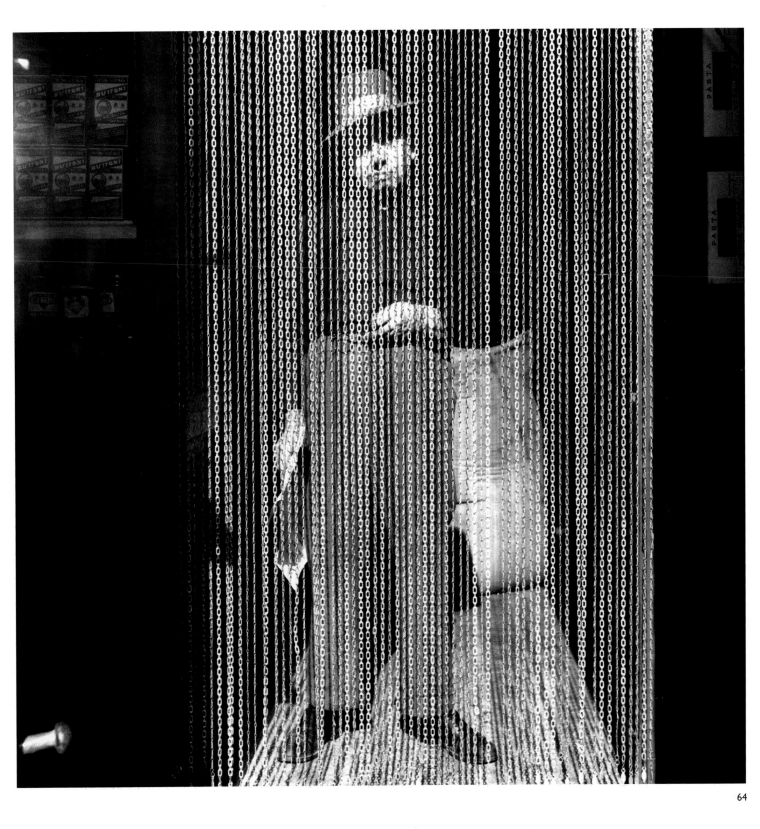

Sometimes I can see
the picture immediately
and then the first exposure
is often the jackpot one

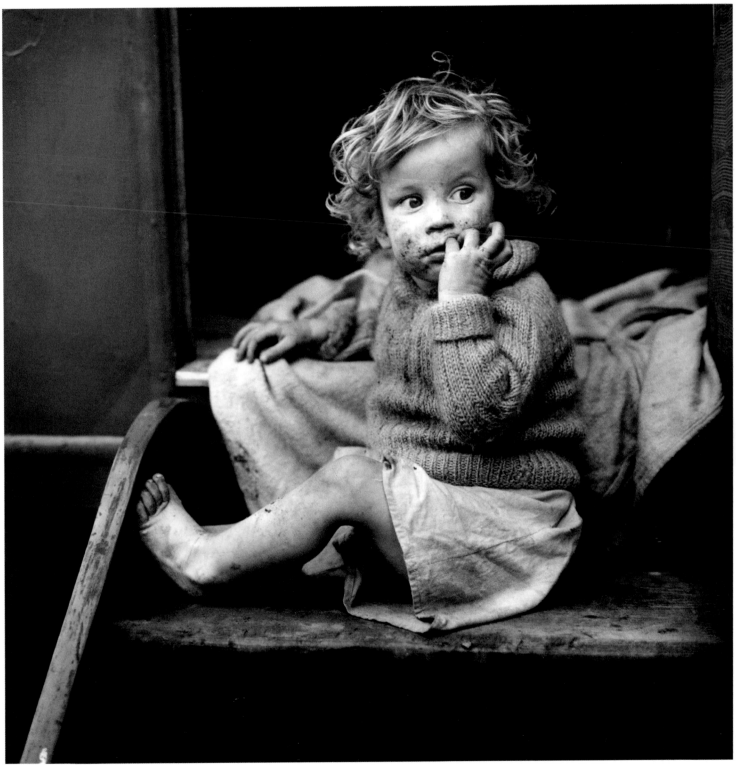

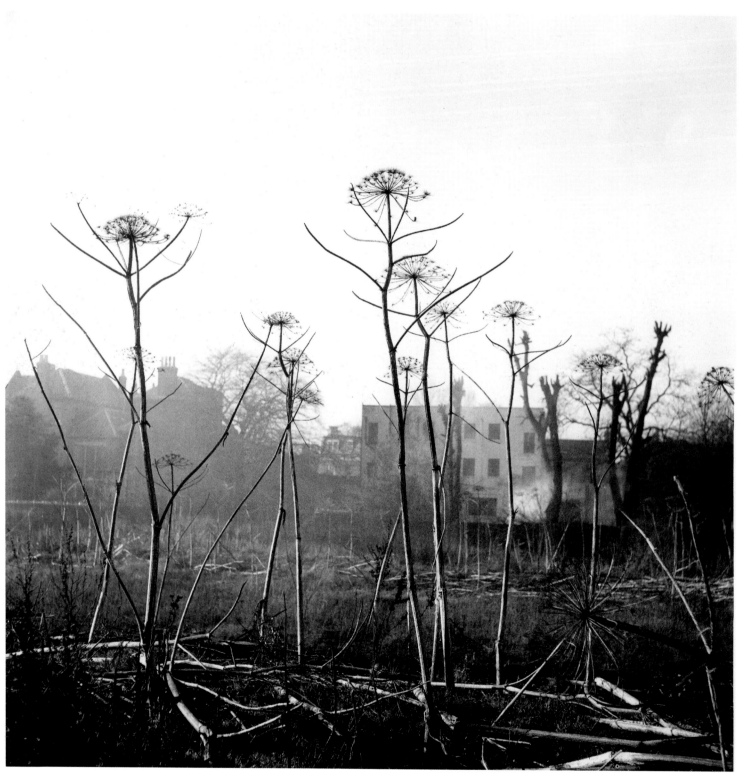

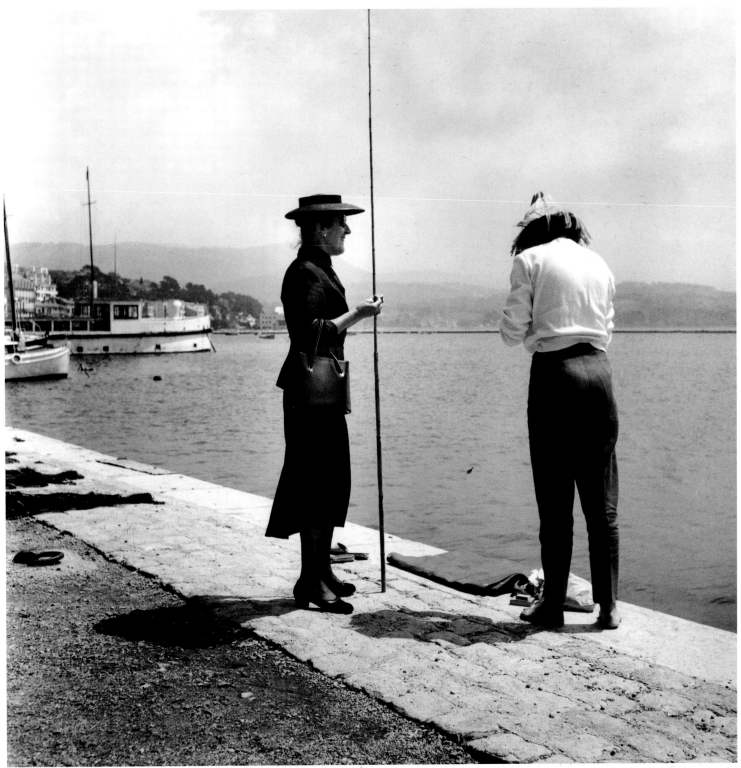

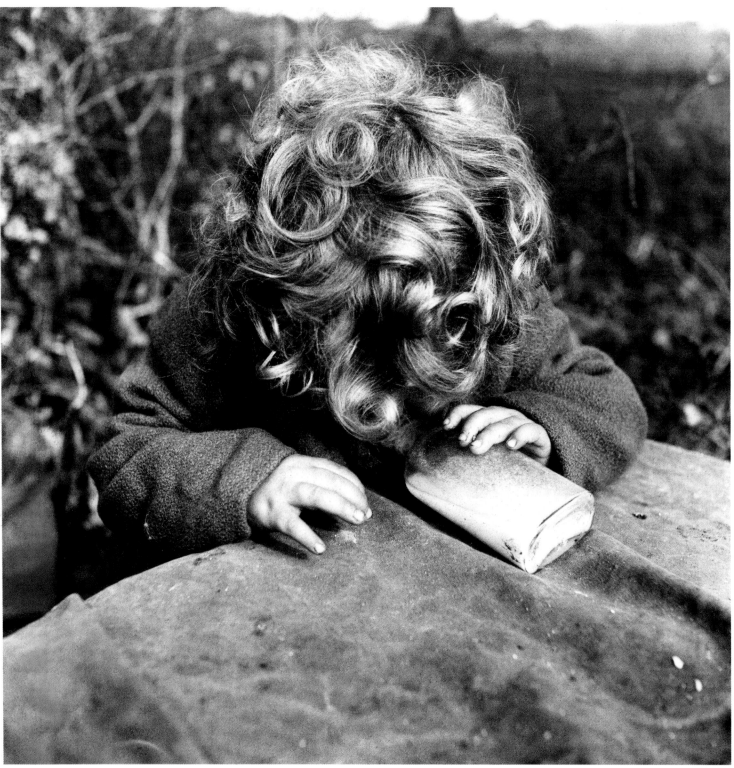

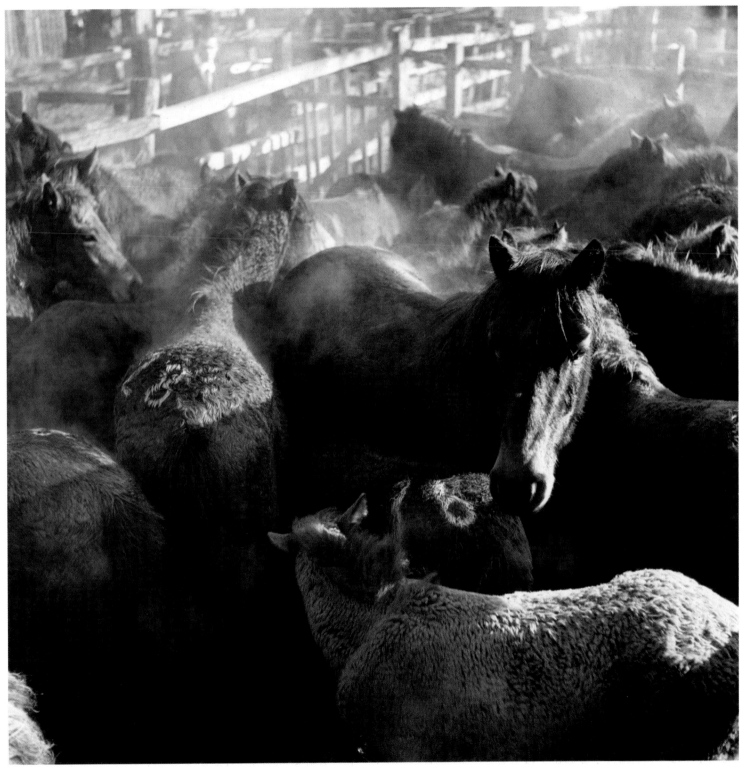

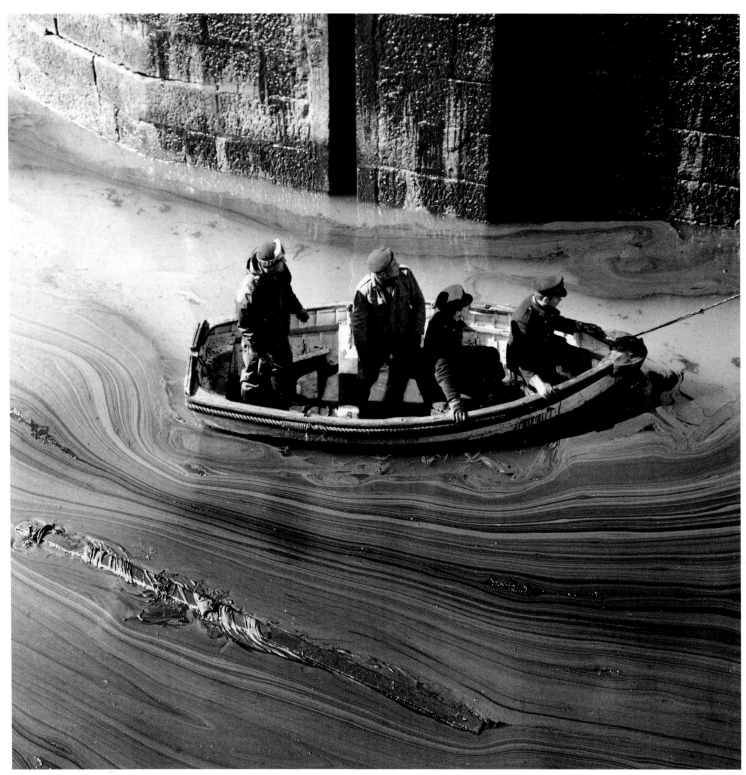

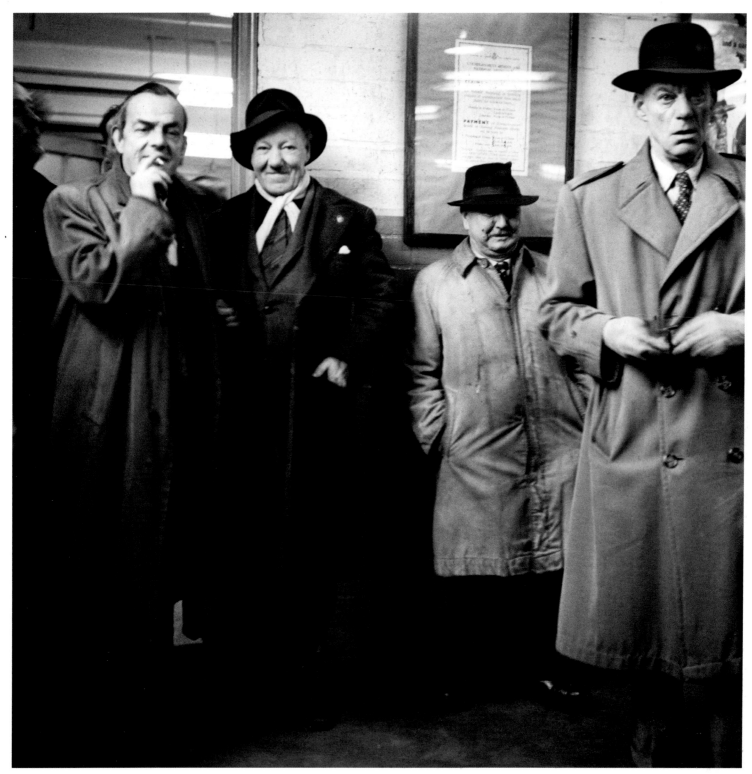

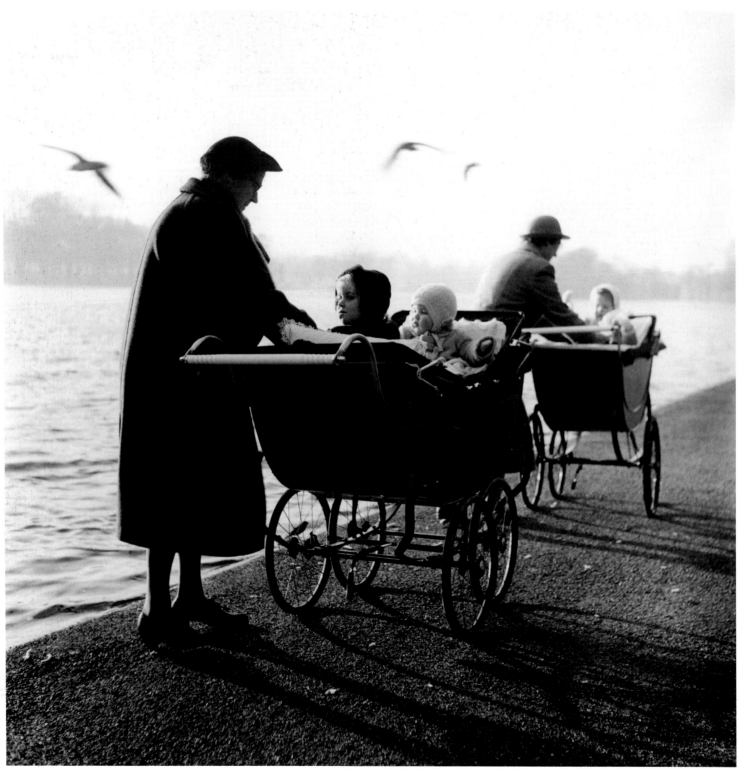

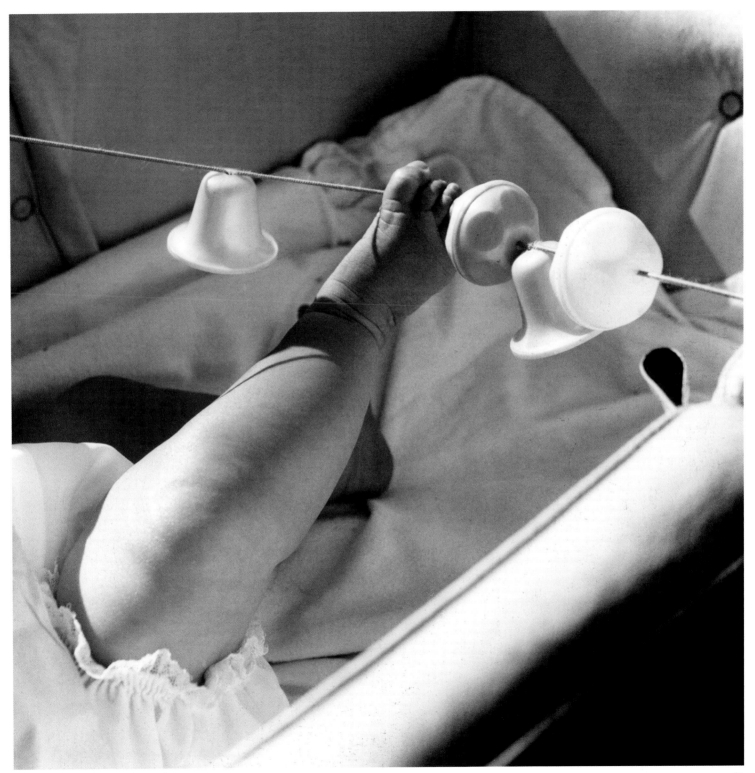

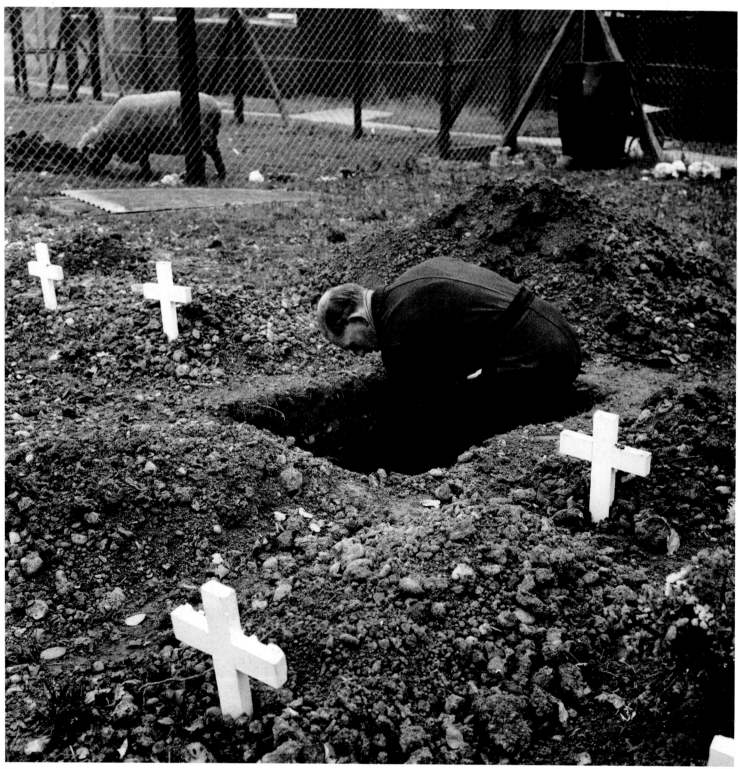

74

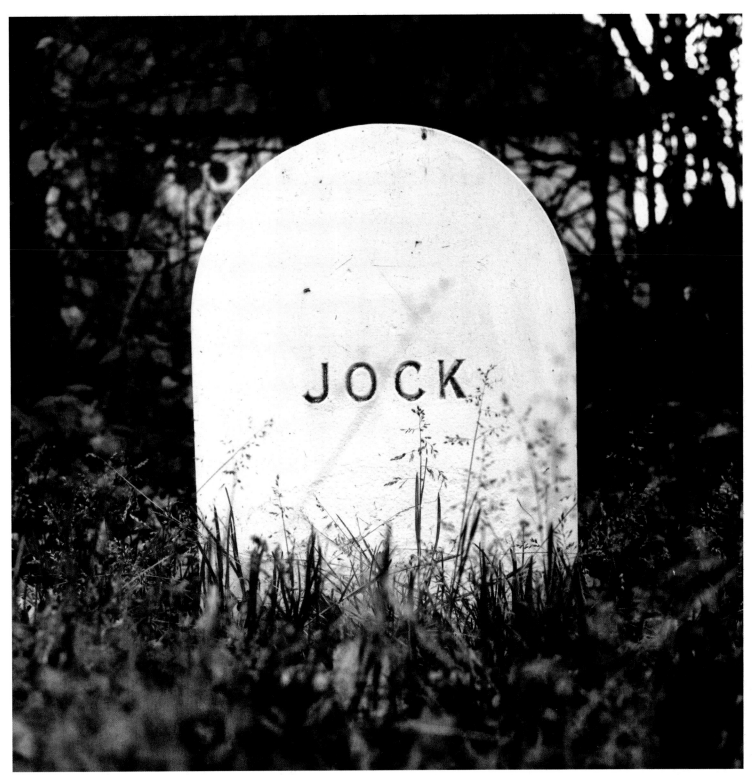

For that moment when I look
through the lens, when absolutely
everything is exactly right, love
is the only way to describe what I feel

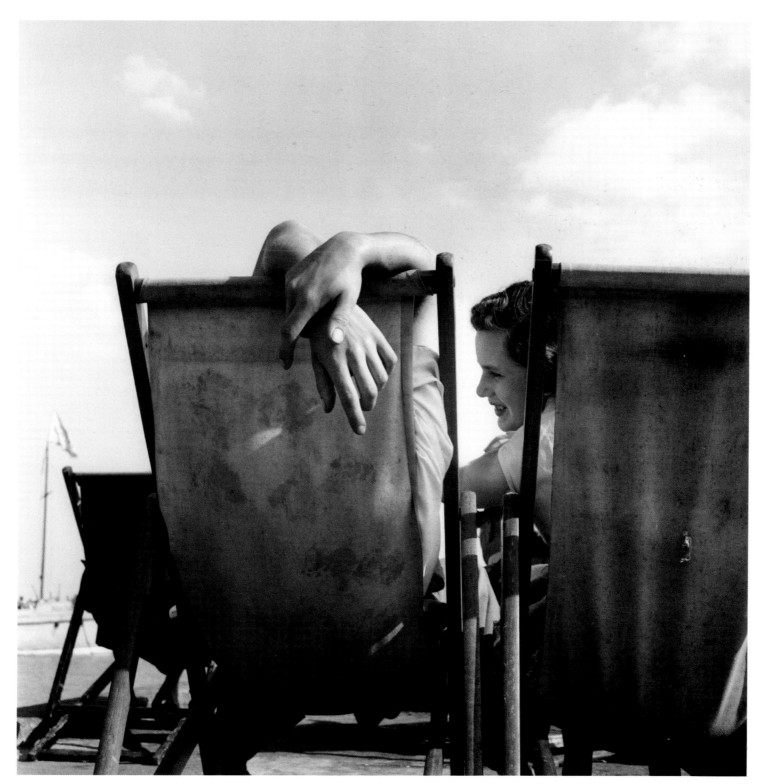

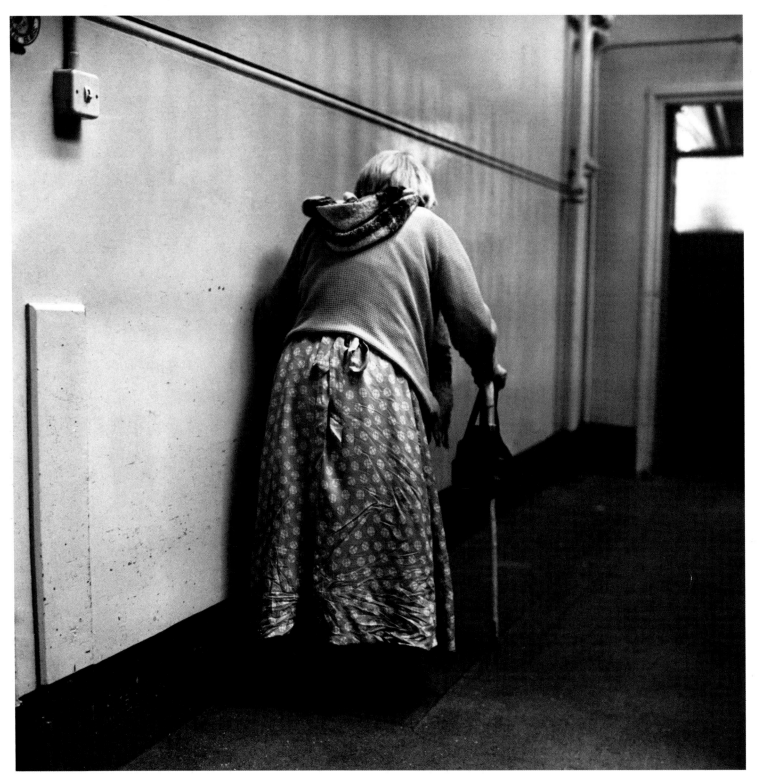

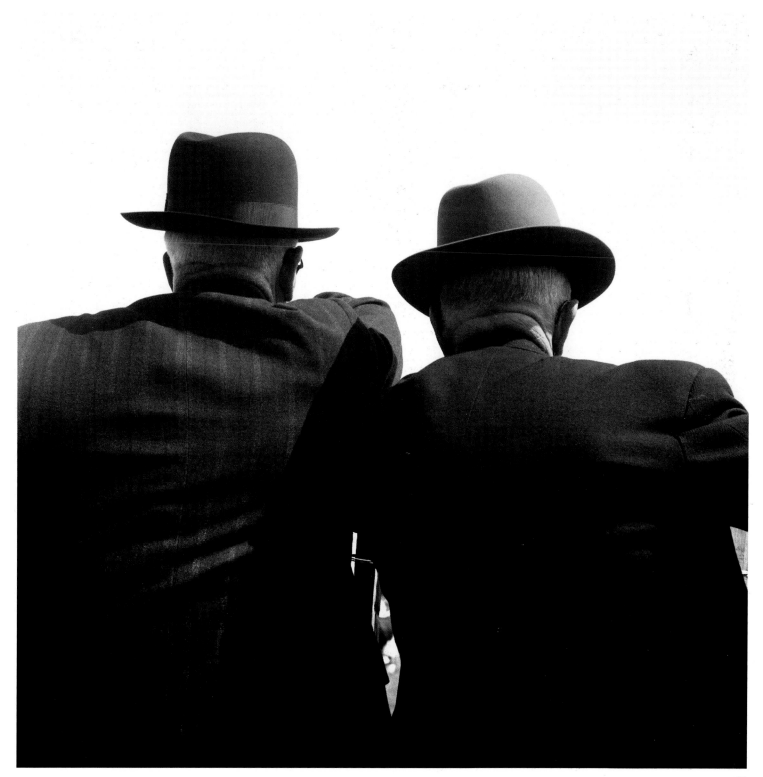

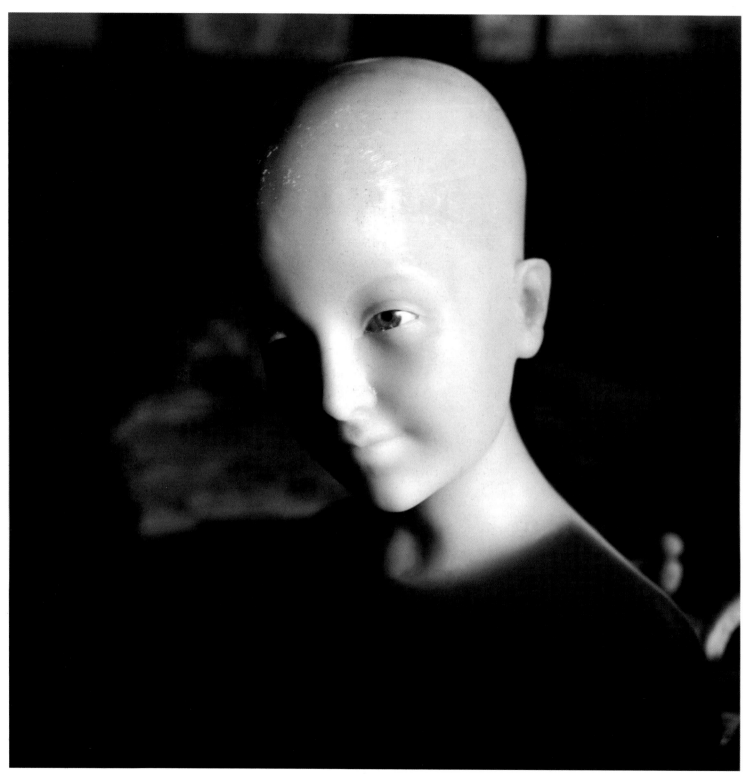

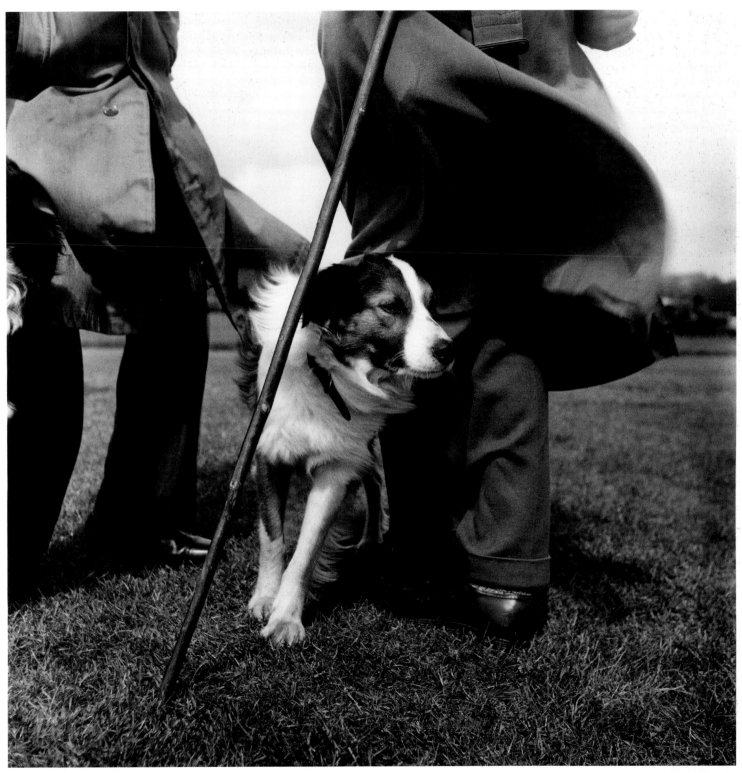

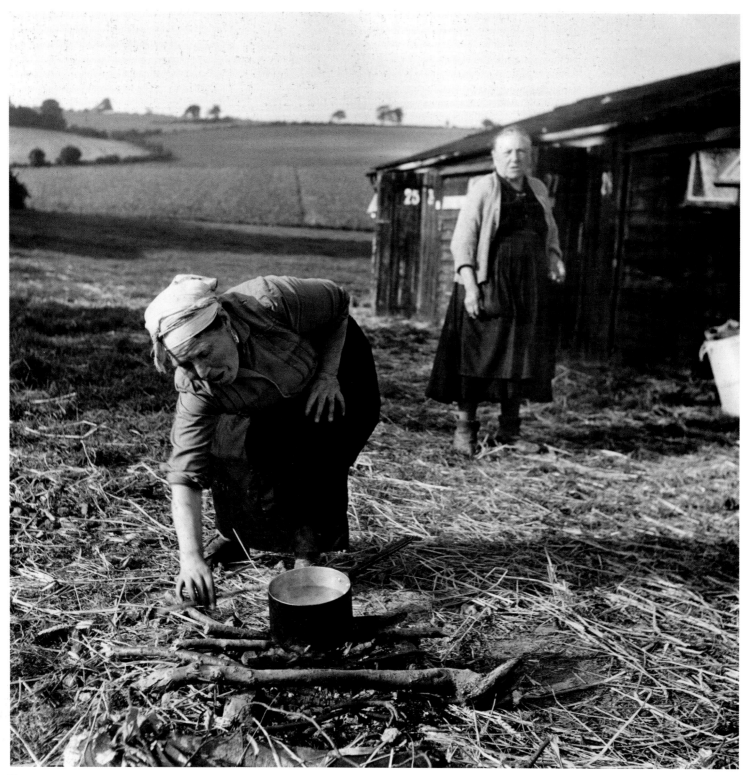

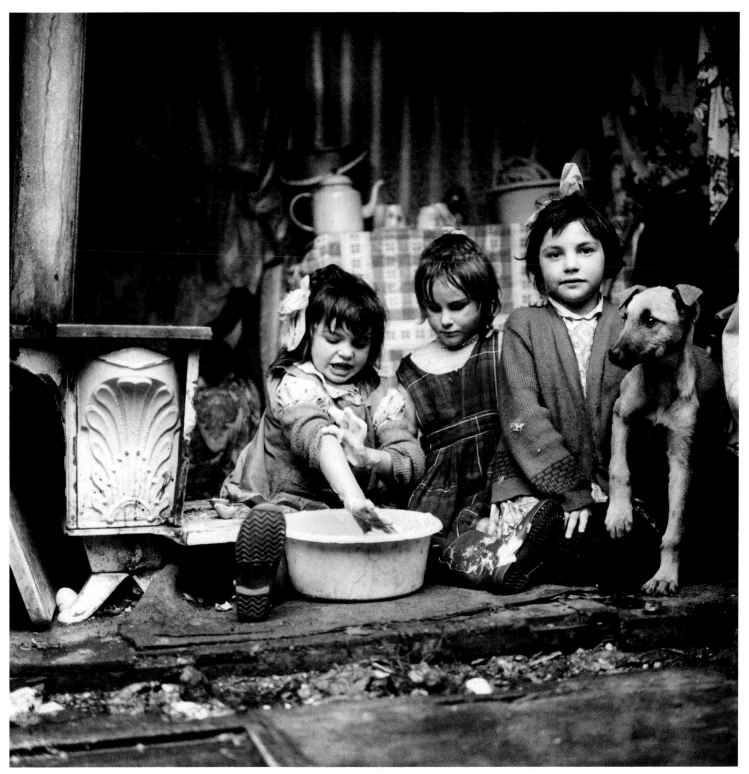

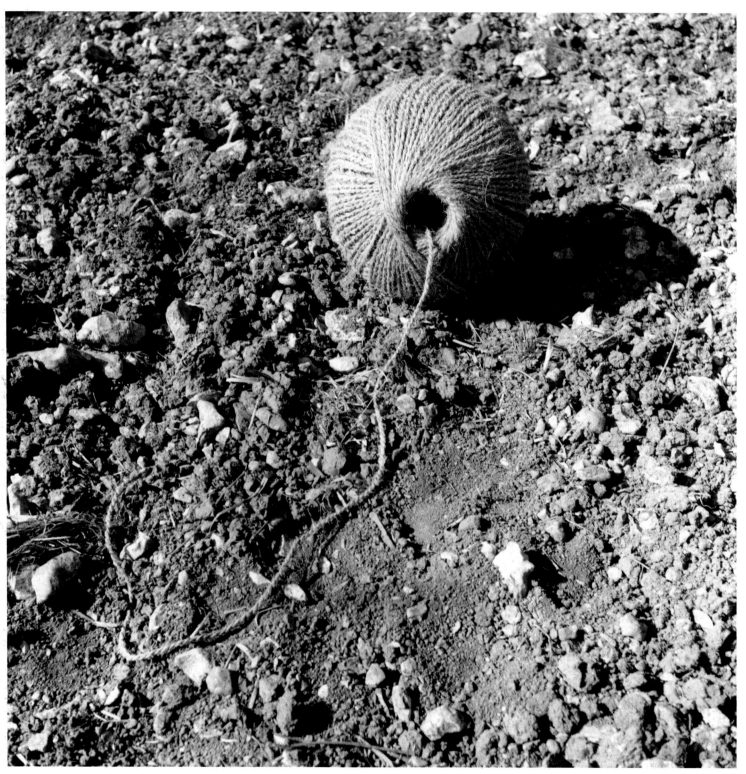

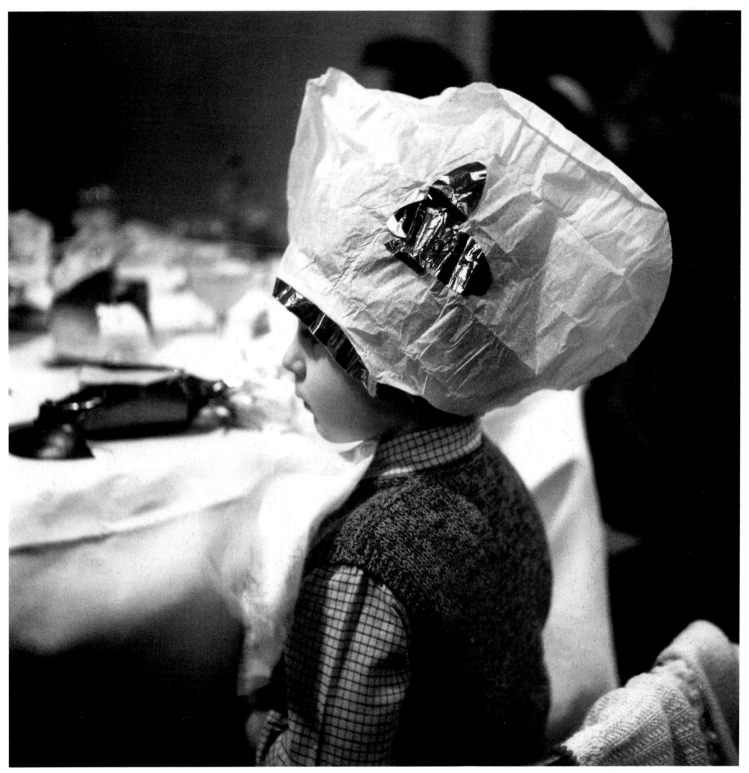

I can't really describe the
sheer excitement I felt when
I looked down into that viewfinder,
twisted the knob and
everything came into focus

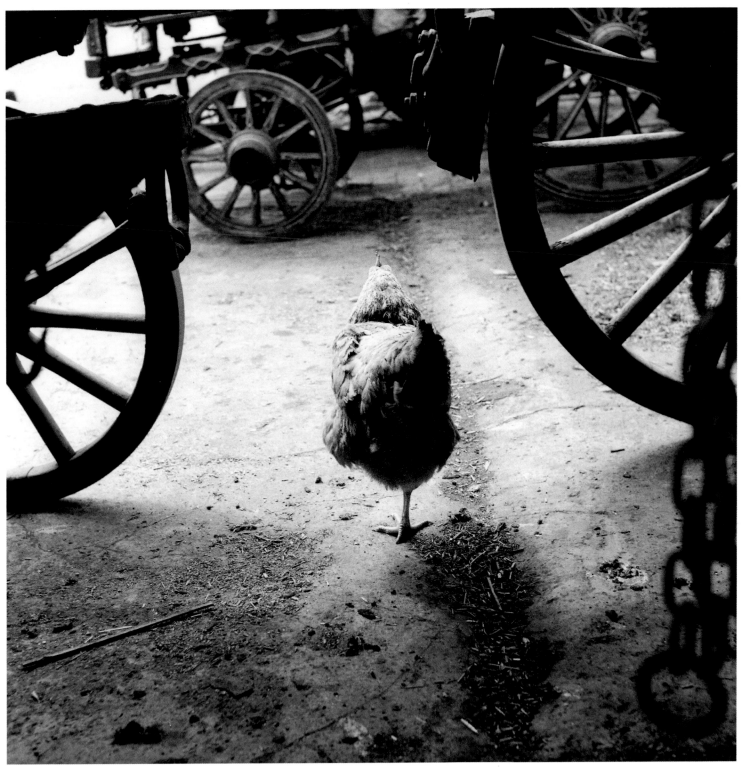

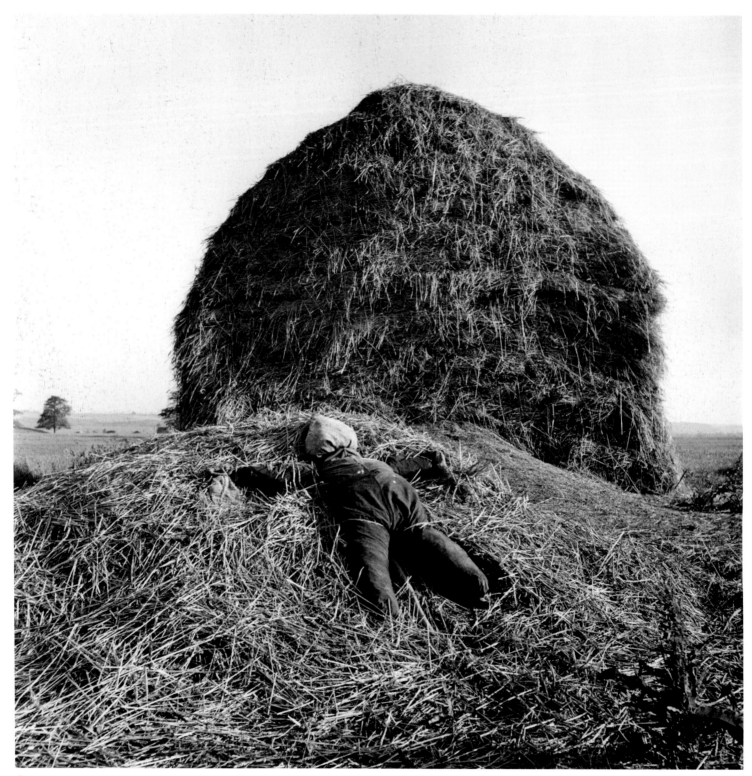

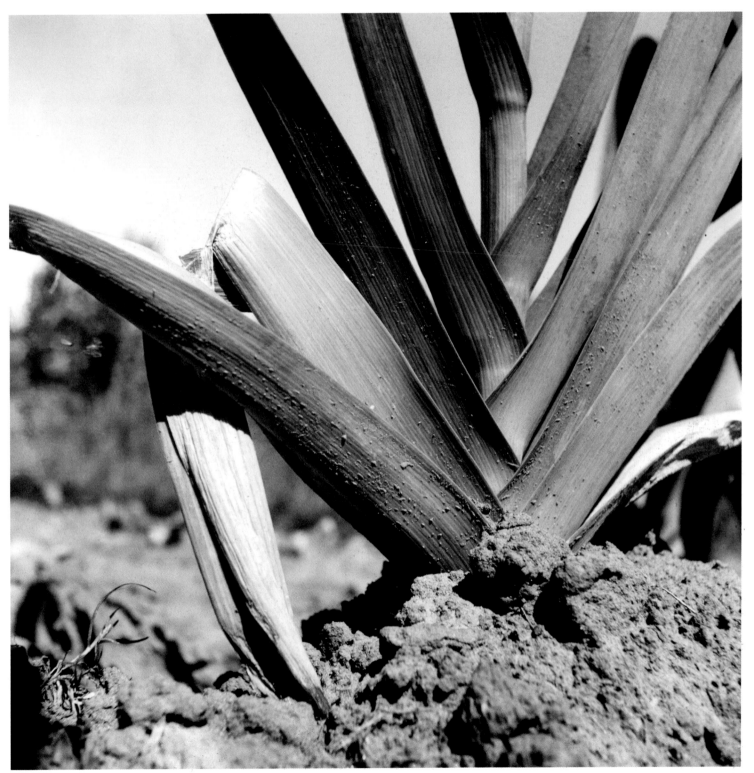

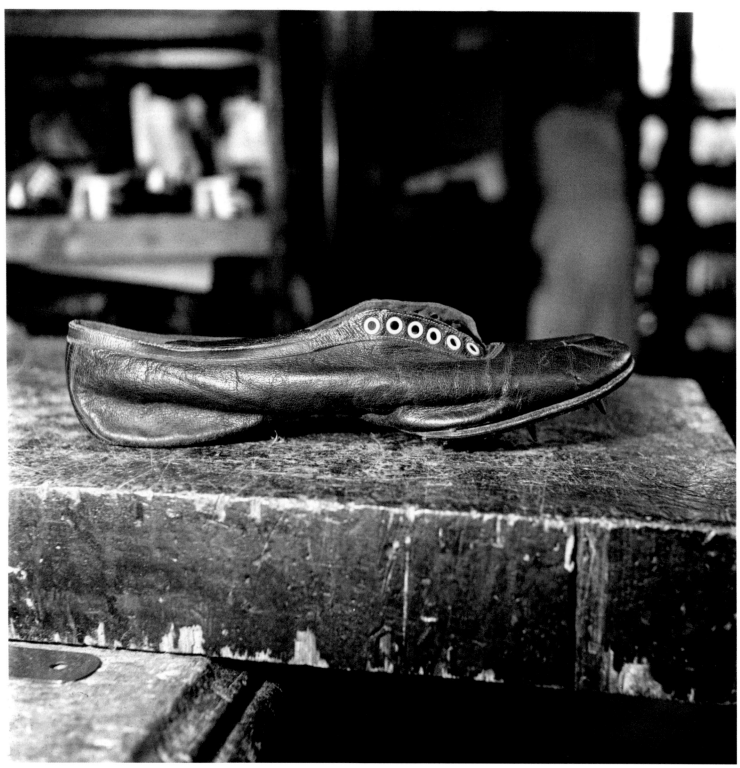

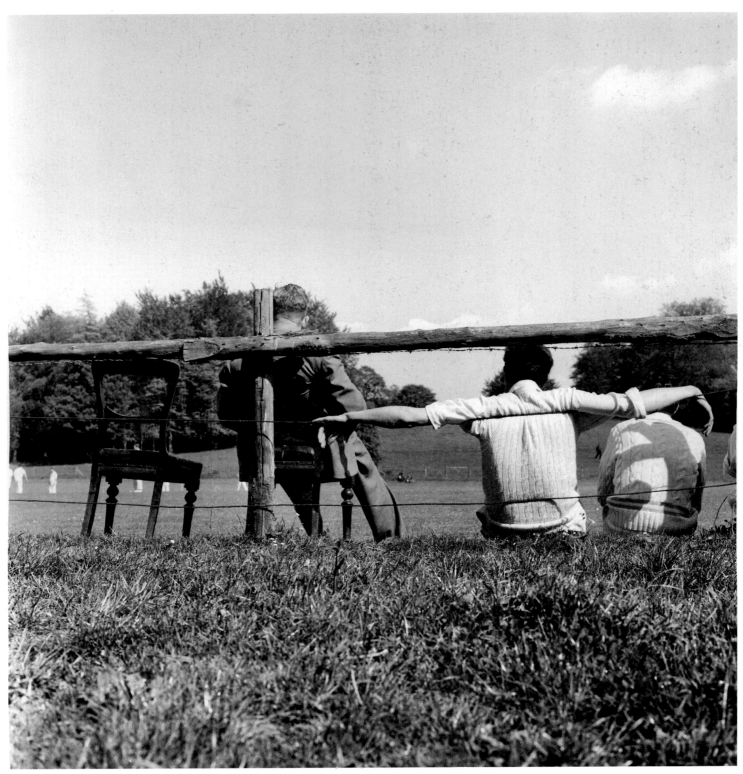

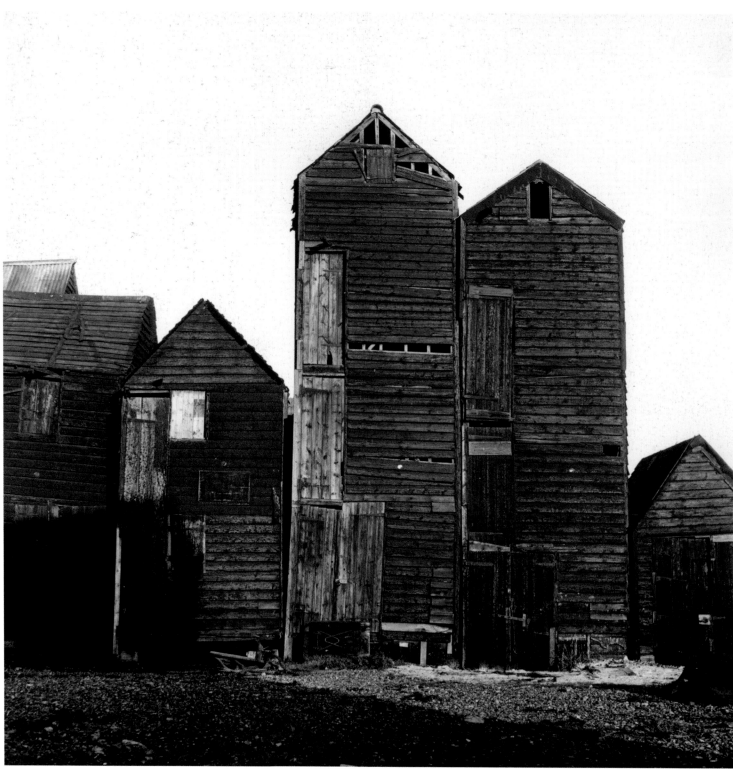

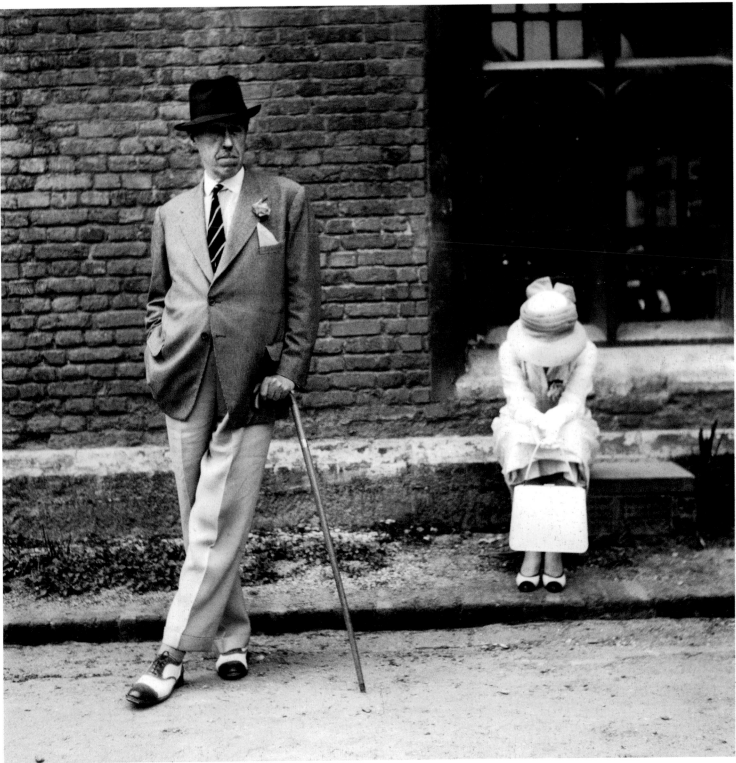

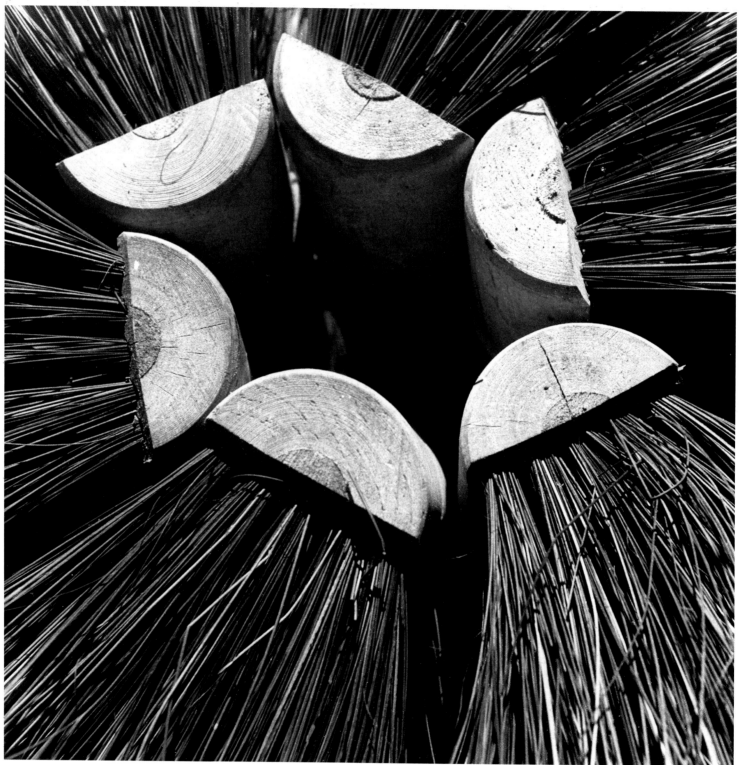

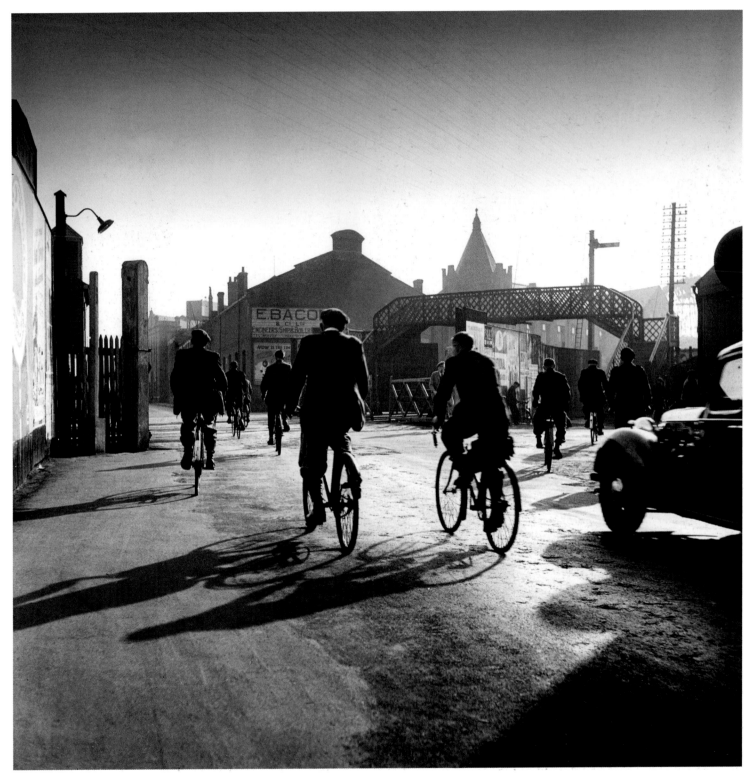

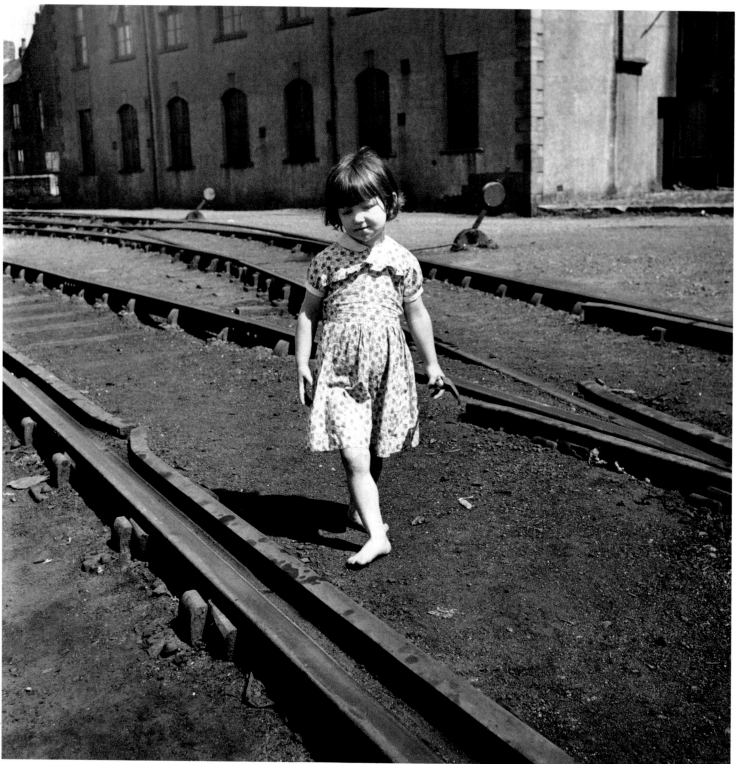

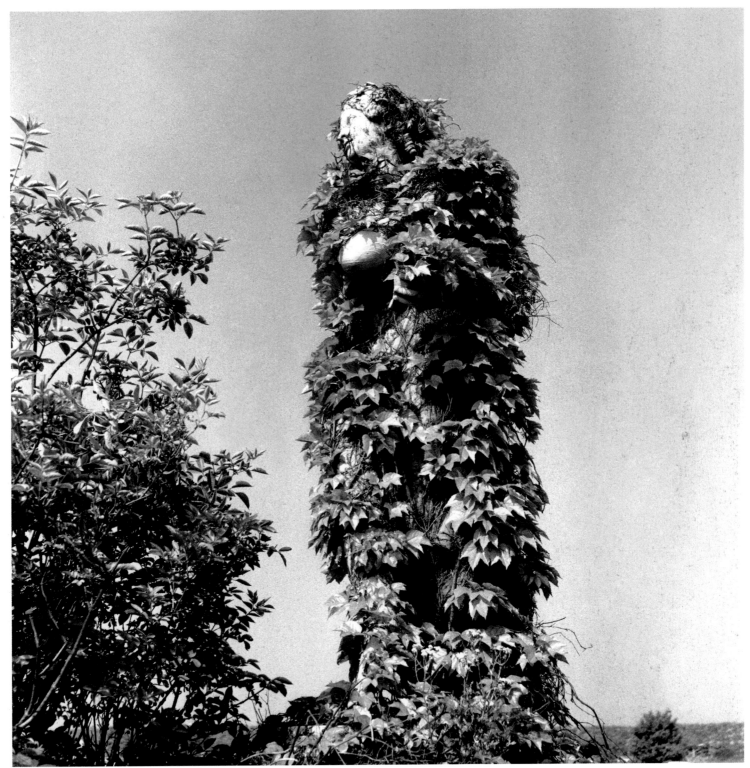

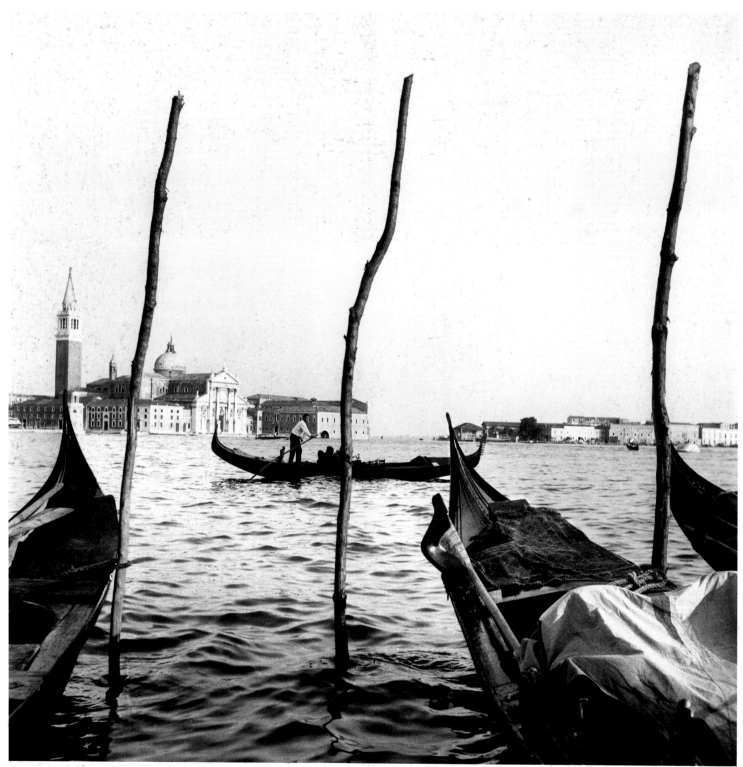

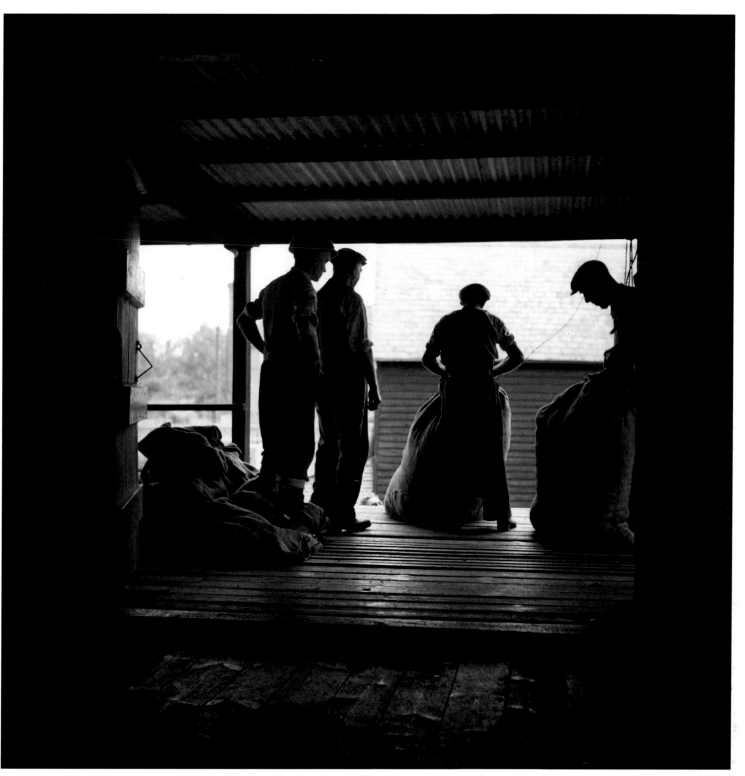

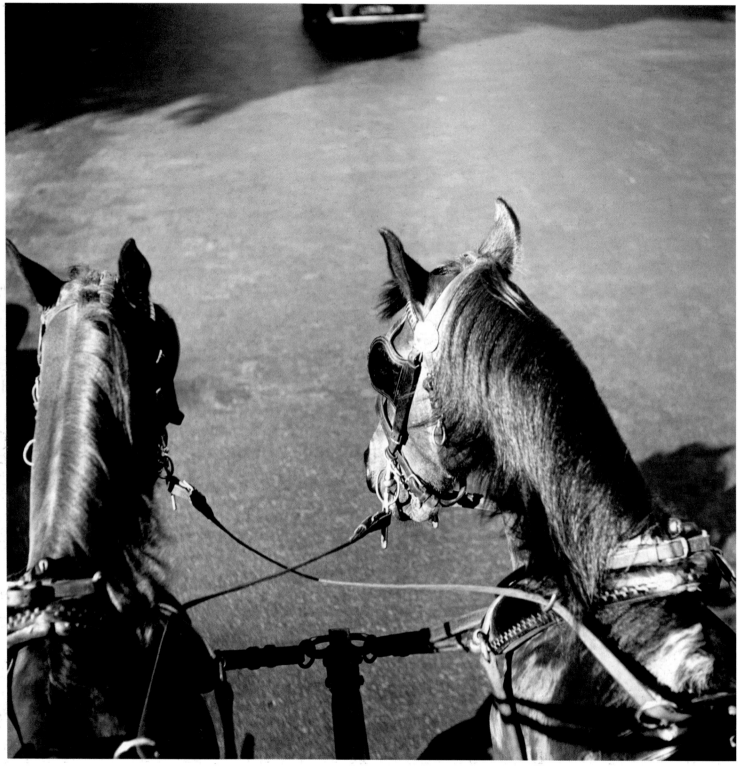

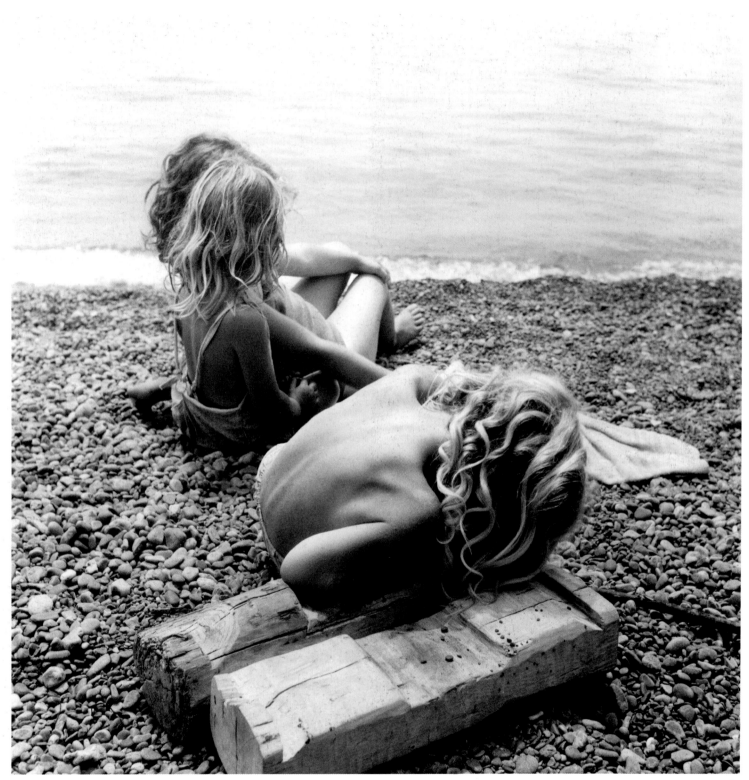

These pictures are the real me

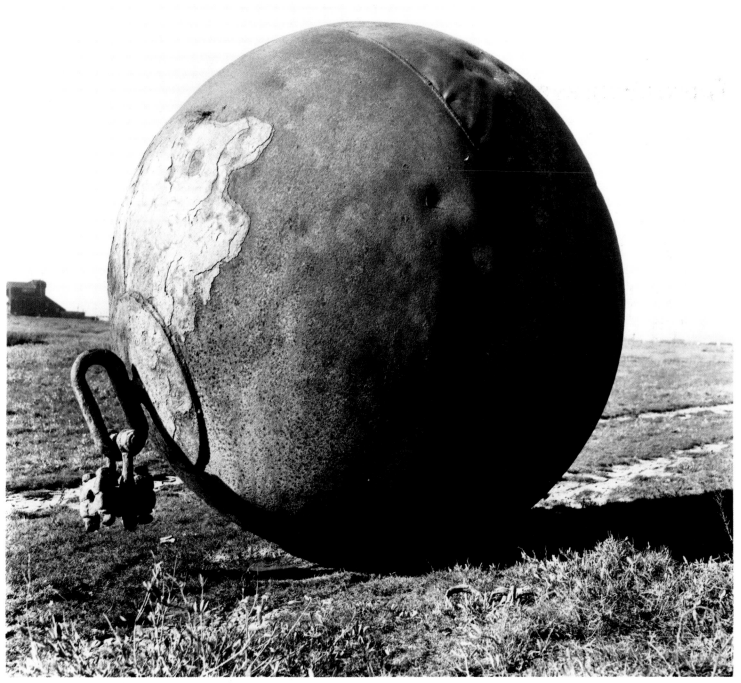

In conversation

Jane Bown in conversation with Luke Dodd, Director of the Newsroom, the Observer and Guardian Archive where the Bown collection is preserved.

LD *How did you become a photographer?*
JB Well, entirely accidentally really. It was immediately after the Second World War and having served in the Wrens I was entitled to a two-year ex-service grant and one of my fellow-Wrens suggested that I try photography. She thought that something visual would be good because of my work as a chart corrector – I plotted the landing maps for D-Day. Guildford School of Art had a course run by Ifor Thomas and his wife Joy and, even though my application was late and the course full, he accepted me because he had served in the Royal Navy Volunteer Regiment.

LD *Had you taken many photographs at that time?*
JB Not one, I didn't even own a camera.

LD *What was the course like?*
JB Thomas was wonderful if a little frightening, initially. He was very good on the correct exposure and development to achieve the perfect negative. He would spend days showing us how to set up lights to photograph something like a hot-water bottle, although I have to admit I had very little interest in that sort of thing.

LD *You were not a model student?*
JB Absolutely not! For the first two terms I sat looking out

the window, literally, and refused to speak – I was very shy then. Thomas more or less gave up on me. Even at that stage, without really understanding why, I knew instinctively that I would never be one of those photographers who spends ages setting up. I'm a one-shot photographer, I work quickly and hate fuss, always have done.

LD *Can you remember the first photograph you took?*
JB Oh yes. It was a college assignment and I was using a borrowed, ancient Gandolfi. I came upon a wonderful church door covered in bosses. That was the first time I felt the excitement. I knew instinctively that I had found something I could do. Often seeing something that would make a perfect photograph made me almost sick with excitement, my stomach would turn over.

LD *Did Thomas approve of your shot of the church door?*
JB Not particularly. But in the second term I borrowed fifty pounds from an aunt and bought my first camera, a second-hand Rolleiflex with a Tessar lens. On Dartmoor one day, I photographed a cow's eye (1) and when I showed this to him his attitude toward me changed, immediately – he saw what I saw, saw what I was trying to do. I could see him looking at me differently. He sort of adopted me after that. And then it became an obsession. I would develop my films at home in the bathtub, working late so that they would dry overnight. I would rise at five or six to print – sometimes I wouldn't be able to wait and got up in the middle of the night. I can still remember the excitement of printing up a good picture.

I was very happy then, cycling around Dartmoor on a bike with no brakes, stopping here and there – there were good pictures everywhere. I was always the first person at college in the morning and the last to leave at night.

LD *It seems to me that you perfected your working method very early, that it has changed little in your six-decade career.*
JB Definitely. It hasn't changed at all.

LD *How would you describe that working method?*
JB I work instinctively, usually going in on a wing and a prayer. Obviously it's very different taking pictures for pleasure and working on an assignment, but generally speaking I like to arrive early to survey the location. Time and daylight are my enemies. But I don't really like plain sailing either. When it's a bit agitated, there's more hope of something different coming out. I work quickly and I hate people around me when I'm working – I've never had an assistant. I rarely expose more than two rolls of film, more than that is usually a sign that things are not going well. Sometimes I can see the picture immediately and then the first exposure is often the jackpot one. Other times I have to work at it a bit and then it's often the last one.

LD *Did you look at and discuss other photographers' work at college?*
JB Never, the emphasis was on taking photographs and perfecting techniques.

LD *There is an incredible consistency to these early photographs in terms of approach, subject matter, technique and framing.*
JB Really? I just remember wandering around seeing things. I was obsessed with textures and patterns – hair, cloth, the grain of a piece of timber, the print of a fabric. I loved allotments, you always got wonderful photographs there. For a time, I took lots of shots of farm machinery and I've always loved photographing children. I honestly think that all my best shots were taken on holiday.

LD *What was going through your head when you took that wonderful shot of the woodsman with the axe (10)?*
JB God only knows! But I remember taking the shot. I came upon him at the roadside and asked him to hold the axe for me. I love the texture of the worn cuff. You can get beautiful textures with a Rollei, it was always wonderful for that.

LD *Several of these early shots are abstract studies, graffiti on a wall, a ball of string. What influenced these photographs?*
JB Probably looking through the lens of the Rollei. I can't really describe the sheer excitement I felt when I looked down into that viewfinder, twisted the knob and everything came into focus – the image was reversed of course. That's something you don't get with 35mm. That photograph of the graffiti would just not have been possible without the Rollei.

LD *How important is camera equipment?*
JB I stopped using the Rollei in the '60s when the *Observer* magazine was launched and started to use a Pentax 35mm,

although for a time I used both. Now I have about a dozen or so Olympus OM1s – all were bought second-hand more than forty years ago. I never use lights or a light meter – I can gauge the settings by the way light falls on the back of my hand. I'm really not precious about equipment, I'm much more interested in what's happening within the frame and, most importantly of all, what the light is like. I have several lenses although I really only use the 85mm and 50mm.

LD *How did you become a photojournalist?*
JB Ifor Thomas said that if you have twelve photographs in a portfolio you can go anywhere in the world so I did just that and hawked them around London. I met Mechthild Nawiasky at the *Picture Post* and when she ended up as the *Observer* picture editor she telegrammed me one day to photograph Bertrand Russell. I was absolutely terrified but managed it and that was my first picture to be published in the *Observer*. And that was it really. I used to work two days a week for which I was paid seven pounds.

LD *I have spent a good deal of time going through the contact prints for this early work and, astonishingly, most of the images are single exposures, all perfectly composed and pin-sharp. Did you never bracket (multiple exposures at different settings to achieve the perfect negative)?*
JB I didn't know how to bracket. It must have been my training, I still don't bracket. I do it the other way around. I have a setting I like to use – 60th of a second and f2.8 – and I usually make the picture work around this. I always thought that would make a good title for a book – 60th of a second and f2.8.

LD *It seems to me that there is nothing incidental about your photographs, that each and every corner of the frame has been considered and that the background is just as important as the main subject.*
JB I tend to be very clear about what I see and know when everything is in exactly the right place. The best pictures are uninvited, they're suddenly there in front of you… easy to see but difficult to catch. Some people take pictures, I find them.

LD *While this book includes some wonderful studies of people, there are almost no portraits even though your reputation is primarily as a portraitist.*
JB I was never interested in portraits – that came later and I was, more or less, forced into it. Mechthild Nawiasky said that if I could photograph a cow's eye I could take portraits. Because I could work quickly, picture editors knew I could be relied on to get the shot so if there was a particularly tricky character or if the time was very limited I would be sent along. My nickname was Tenacity Jane! Most of the early portraits I took are ghastly, silly little things. They were straightforward head and shoulder shots to illustrate a profile and there was very little room for manoeuvre. Later, when I became good at it, David Astor (*Observer* editor 1948-1975) would always seek me out after a shoot to see what impression I had of the subject.

LD *Many of the shots of people in the book seem to have been taken surreptitiously. There is very little direct address to camera.*
JB I was in my twenties when most of these shots were taken and very reserved. I was finding my way, I suppose.
And I've always liked, if possible, to work unobtrusively.
I love train stations and airports, places with lots of people where I can blend into the crowd and work unobserved.

LD *What is the main difference between photographing people unobserved and looking them directly in the eye?*
JB When somebody looks you in the eye, eyeball to eyeball, it's pretty amazing.

LD *The thing that links all of the photographs in the book is that they are non-didactic. They serve no other purpose than as pure photographs.*
JB Is that not the way photographs should be?

LD *Have you ever worked in colour?*
JB Yes, for about three years in the 1960s but I was never comfortable with it. In those days, colour was very inflexible – I had to learn to bracket then. With black and white it's usually possible to salvage something in the darkroom however bad the shoot might have been. And with colour, editors tended to want photo essays and I was always best at the single shot. I'm a one-shot girl, always have been!

LD *Unlike many of your contemporaries, you rarely worked abroad or felt the need to cover conflict or famine.*

JB I'm wary of that kind of photography – it's too easy to take photographs abroad or in a war or famine. I did go to China once and have some wonderful pictures but none of them have ever been published.

LD *Some of the photographs in the book were cropped when originally published. Does this bother you?*
JB Not at all. Picture editors tend to use what they need and I suppose people became more used to looking at a 35mm frame. But all of my Rollei pictures were taken with the full frame in mind and it's good to see them printed like this. These pictures are the real me.

LD *What about the state of photography now?*
JB I think it has all gone too far. It was so lovely at the beginning – exciting, revealing. Now we all see too much, there are too many photographs, too many photographers all chasing the same subject, and less chance to be original. And people are wiser to it all – too aware. I timed it perfectly maybe. I started off learning how to prepare glass-plate negatives and now film is nearly obsolete. I could no more contemplate using a digital camera than travel to the moon.

LD *Do you still feel excitement taking photographs?*
JB Oh yes! For that moment when I look through the lens, when absolutely everything is exactly right, love is the only way to describe what I feel.

Jane Bown's Rolleiflex. Photograph by Dan Chung

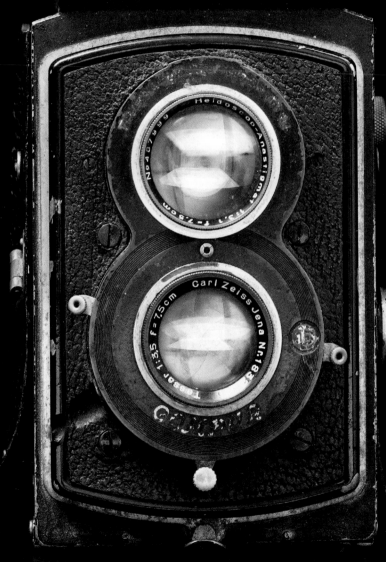

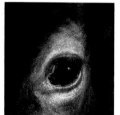

1 Cow's eye, Dartmoor,
Devon, 1947

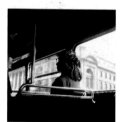

2 Hop-pickers at dawn, 1956

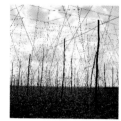

3 Hop fields, Bentley,
Hampshire, 1950

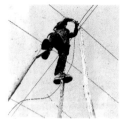

4 Man on stilts, hop fields,
Bentley, Hampshire, 1950

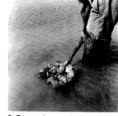

5 Oyster harvesting,
Colchester, Essex, 1950

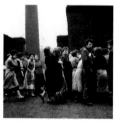

6 Channel crossing, 1955

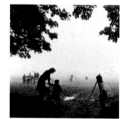

7 Spectators,
Wimbledon, 1952

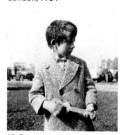

8 Venice, Italy, 1952

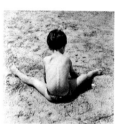

9 St Tropez, France, 1957

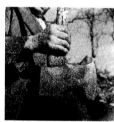

10 Woodsman, c.1950

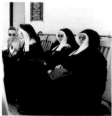

11 Rochdale, by-election, 1958

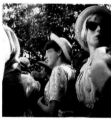

12 Circus performers,
Farnham, Surrey, 1956

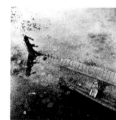

13 Press Corps awaiting
President Eisenhower, 1959

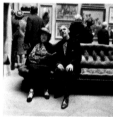

14 Royal Academy,
London, 1964

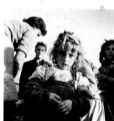

15 Gypsy child, Maidstone,
Kent, 1961

16 Meat shortage,
Penzance, 1951

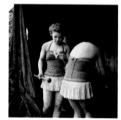

17 City of London
Festival, c.1960

18 Graffiti, c.1955

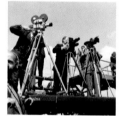

19 Gypsy boy,
Maidstone, Kent, 1961

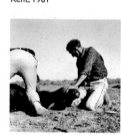

20 Camargue, France, 1950

21 Wig-makers' shop,
London, 1949

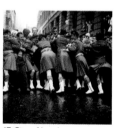

22 Wig-makers' shop,
London, 1949

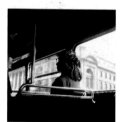

23 Woman on bus,
London, 1954

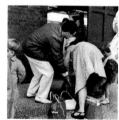

24 Butlins, Clacton-on-Sea,
Essex, 1961

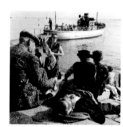

25 Southend-on-Sea,
Essex, 1954

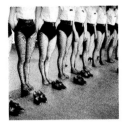

26 The Tiller Girls, ATB
Studio, Boreham Wood, 1962

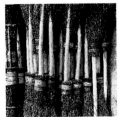

27 Brooms, c.1955

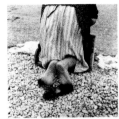

28 Washerwoman,
Lake Garda, Italy, 1953

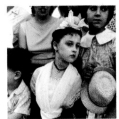

29 Camargue, France, 1950

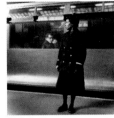

30 Earls Court
Underground, c.1960

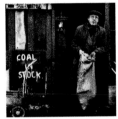

31 Fuel crisis, East End,
London, 1957

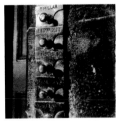

32 Name plaque,
London, c.1955

33 Virginia creeper, c.1950

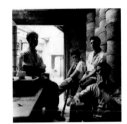

34 Potteries,
Stoke-on-Trent, c.1960

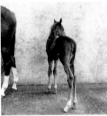

35 National Stud, 1953

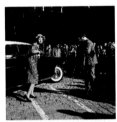

36 Fashion shoot,
Florence, Italy, 1958

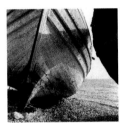

37 Lake Garda, Italy, 1953

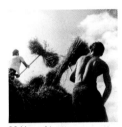

38 Haymaking,
Hampshire, 1958

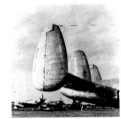

39 Farnborough Air Show,
Hampshire, 1949

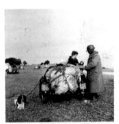

40 Hog's Back, Farnham, 1953

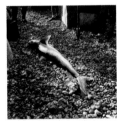

41 Young shark, Amalfi coast,
Italy, 1956

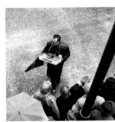

42 Poppy Day, London, c.1965

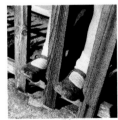

43 Feet through fence,
Hampshire, c.1955

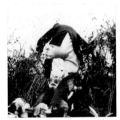

44 Beagling, Boxing Day meet,
Hampshire, 1956

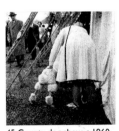

45 County dog show, c.1960

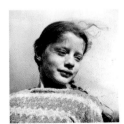

46 Margaret Alderman,
Ashbrittle, Somerset, 1949

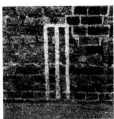

47 The Latymer School,
London, 1963

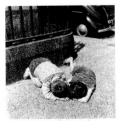

48 Children on pavement,
Dublin, c.1960

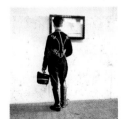

49 Royal Tournament,
Earls Court, London, 1956

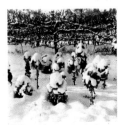

50 Brussels sprouts
in snow, 1957

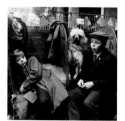
51 Crufts Dog Show,
Earls Court, London c.1960

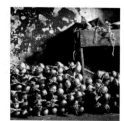
52 Onions, Battersea, 1961

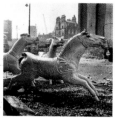
53 Roundabout horses,
London, 1952

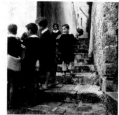
54 Venice, Italy, 1956

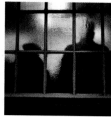
55 Unemployment exchange,
Bristol, 1959

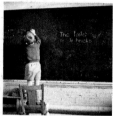
56 Boy at blackboard,
Wakefield, Yorkshire, 1964

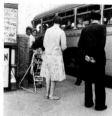
57 Sidmouth, Devon, c.1960

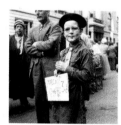
58 Deck chair girl,
London, c.1960

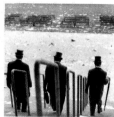
59 Ascot, Berkshire, 1961

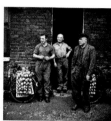
60 French onion sellers,
Battersea, 1961

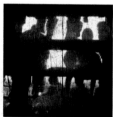
61 Spectators at the Palio di
Siena, Siena, Italy, c.1955

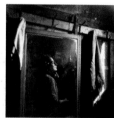
62 French onion seller,
Battersea, London, 1961

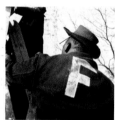
63 Cromwell Road extension,
London, c.1960

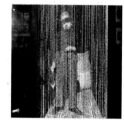
64 Shopkeeper, Amalfi coast,
Italy, 1956

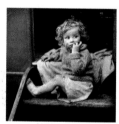
65 Gypsy child, Maidstone,
Kent, 1961

66 Bombsite, London, 1958

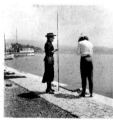
67 France, c.1955

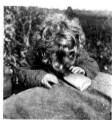
68 Gypsy child with bottle,
Dorset, 1954

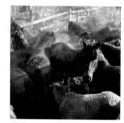
69 Bampton Pony Fair,
Devon, 1950

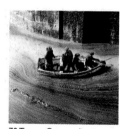
70 Torrey Canyon disaster,
Cornwall, 1967

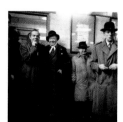
71 Unemployment exchange,
Bristol, 1959

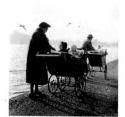
72 Nannies, Hyde Park,
London, 1957

73 Louisa Moss, 1959

74 Kennels, Bushey,
Hertfordshire, 1961

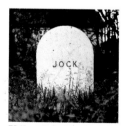
75 Kennels, Bushey,
Hertfordshire, 1961

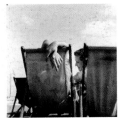

76 Southend-on-Sea, Essex, 1954

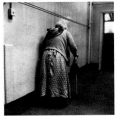

77 Luxborough Lodge, Marylebone, London, 1963

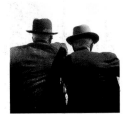

78 Race meet, c.1960

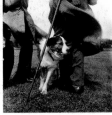

79 Waxwork, Notting Hill, London, c.1955

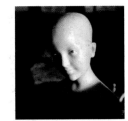

80 Sheep Dog Trials, Hyde Park, London, 1958

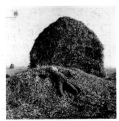

81 Gypsies, Bentley, Hampshire, 1955

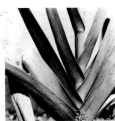

82 Gypsy children, Hertfordshire, 1966

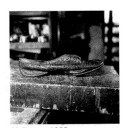

83 Ball of string, c.1955

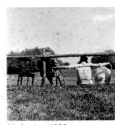

84 Child at Christmas party, London, 1960

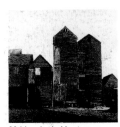

85 London mews, 1954

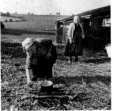

86 Scarecrow, c.1955

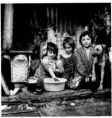

87 Leek, c.1955

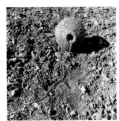

88 Shoe, c.1955

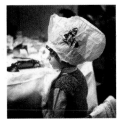

89 Cricket, 1958

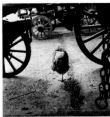

90 Net sheds, Hastings, East Sussex, c.1955

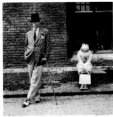

91 Eton Day, 1952

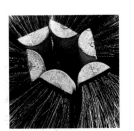

92 Brooms, c.1950

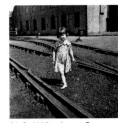

93 Grimsby Dockers, Lincolnshire, 1962

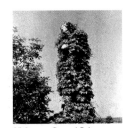

94 Girl, Whitehaven Quay, Cumbria, 1964

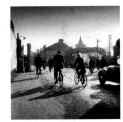

95 Statue, Crystal Palace, London, 1952

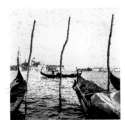

96 Venice, Italy, 1956

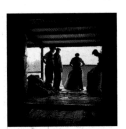

97 Docks, London, c.1955

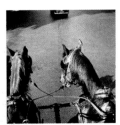

98 Piccadilly, London, c.1960

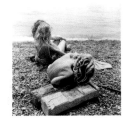

99 St Tropez, France, 1957

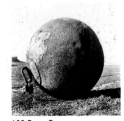

100 Buoy, Rye, East Sussex, 1953

Designed by Mark Porter
Design assistant, Gina Cross
Reproduction by Olly Spratley
Photographic printing by
Kath Dixon, Metro Imaging
Printed by Graphicom Srl, Vicenza, Italy
With special thanks to
Robin Christian and Gareth James

This book was made possible through the
generosity of a donor in Concord, Massachusetts,
who would like to remain anonymous.

First published in 2007 by Observer Books,
119 Farringdon Road, London EC1R 3ER
www.observer.co.uk

ISBN: 978-0-85265-076-9